IMAGES
of America

LOUISVILLE

IMAGES
of America

LOUISVILLE

Daniel Jay Grimminger, PhD,
and Justus Abraham Friedrich Grimminger

ARCADIA
PUBLISHING

Published by Arcadia Publishing
Charleston, South Carolina

Printed in the United States of America

Library of Congress Control Number: 2023937926

For all general information, please contact Arcadia Publishing:
Telephone 843-853-2070
Fax 843-853-0044
E-mail sales@arcadiapublishing.com
For customer service and orders:
Toll-Free 1-888-313-2665

Visit us on the Internet at www.arcadiapublishing.com

This work is dedicated to Diane Clark (1956–2021), a true, loyal, and cherished friend to our entire family. Requiem aeternam dona ei, Domine, et lux perpetua luceat ei. Requiescat in pace. *Amen.*

CONTENTS

Acknowledgments

This project has been a work of love that took many hours and a lot of energy to complete. When we first discussed it with Ron and Betty Derry and Rhonda Dahlheimer, they were enthusiastic about it and offered the Louisville-Nimishillen Historical Society collections for our use. Over the course of a year, they gave us access to the files, images, and artifacts housed in the historical society space in downtown Louisville, oftentimes putting their own work on hold or moving it to a different space so that we could scan materials. We are very grateful to them for their kindness and encouragement and for sharing their extensive knowledge with us.

We would also like to thank Mark Brunner, whose expert knowledge and informative books have been invaluable. Thanks to Tim Yoder, postmaster Jeffrey Wheeler, Charlene and Junior Grimminger, Mike Grimminger, Julia Grimminger, Mayor Pat Fallot, Theresa Marks (Paradise United Church of Christ), Rev. Dr. David Anderson (Paradise United Church of Christ), the staff at Louisville Public Library, and those who are no longer here in body, namely Jay Lutz Sr. These folks helped us in various ways, from sharing information to giving encouragement.

All of the images in this book are from the Louisville-Nimishillen Historical Society collections unless otherwise noted. Some images are original photography by Justus Grimminger and one is a drawing by Julia Grimminger.

INTRODUCTION

Louisville, Stark County, Ohio, was a town surrounded by farm pastures and fields. Yet early settlers here proved that cultural and religious diversity were possible, even in rural Ohio. The town's founders, Henry Lautzenheiser and George Frederic Fainot, came from very different places—theologically and culturally—but what they created was a town that fostered community and mutuality. This was unique. In very few places in the world at that time could one experience Protestants and Catholics working together. It was equally rare to see Germans and Frenchmen cooperate with each other. Yet, in other ways, Louisville was like other Ohio and Pennsylvania towns: it had a very high population of Pennsylvania Dutch speakers, music and the arts became increasingly important, and divine worship was an expression of who Louisvillians were and what they held dear.

Residents of the town easily could have adopted the motto of the Benedictine monks as their own: *Ora et Labora* ("Pray and Work"). One of the first things that they did was establish churches because faith was so important to them. Roman Catholics were some of the earliest, but French Baptists and Dunkards came very early too. Methodist circuit riders came by on horseback when they could, and the German Reformed sang the German hymns with all of their structure and depth. A number of the congregations in Louisville worshiped in the French Baptist church building at one time or another, and the great friendship between Fr. Louis Hoffer (Catholic) and Pastor John Leberman (Reformed) in the mid-1800s schooled the city in what it meant to love one's neighbor. Louisvillians thrived in faith and vocation.

Prosperity existed here also because of the farming families that were industrious and modest in what they required to live. These were also the people who started businesses and supported businesses. They learned how to do things when they needed to, and they were able to pull on things that they learned long before so that needs could be met, both in their families and in their community. Yes, there were some who came to Louisville with more than modest means. They without a doubt had an advantage and more opportunities, as wealthier people always do. But Louisville provided a place where everyday families could put their roots down and share with each other in ways that money could not buy.

By the time the Swiss-born itinerate artist Ferdinand Brader came through Nimishillen Township in the 1880s and 1890s and sketched what he saw, Louisville was already complimenting the work of the farm with industries like brewing and brickmaking. Eventually, steel and other industry moved into the town, employing many who once would have been plowing soil and harvesting crops. Yet farming, especially dairy farming, remained viable in the township throughout the 20th century. Herschel Levit's WPA painting *Farm and Mill*, hanging in the Louisville Post Office, provides a visual summary of the industrious people of Louisville.

It is unfortunate that Louisville developed a closed mentality over time to anyone who was not from Louisville. That was a common problem in many small communities. The Ku Klux Klan, having one of its strongest chapters in the Dayton, Ohio, area, made inroads in Louisville. But

other problems sprang up as well. As the 20th century progressed, the downtown businesses had problems making ends meet, and many shopkeepers closed their doors for good, as they found it difficult to compete with chain store prices, the convenience and variety in newer stores, and more convenient parking.

More recent problems continued to mirror the larger American culture. The call for fairer work contracts for teachers led to a strike, looking much like labor disputes in other American public school districts. Political unrest building up to the 2020 presidential election spilled over into Louisville when the mobile Trump rally blew through the city and profane flags were proudly displayed by some around town; Black Lives Matter supporters also came to town for a peaceful demonstration at the square. Yet even more recently, a homicide in one of Louisville's city parks, involving victims and perpetrators who were all young, reminded Louisvillians that these things can happen in Louisville, too. In the face of challenges, Louisvillians can look to previous generations who have gone on before; the voices of the fathers speak through story, and those voices have the power to help us look with wisdom on the issues we face right now.

Today, there is a renewed interest in working together and welcoming outsiders into the city. Now, the town can boast that it is making its way back to that earliest vision of Lautzenheiser and Fainot. There are African Americans in the Louisville public schools and in Louisville congregations; Latinos work on local farms and have an increasing presence around the township. At least one church in Louisville holds services in Spanish. Schoolchildren are enriched by others who are not exactly like they are. The vision carries over into physical spaces: city parks have flourished with increased use, art events have given many a newfound expression, new businesses have brought life to downtown, and community is being restored through such things as Second Fridays, Umbrella Alley, and Uptown Joe coffee shop. Ministerium clergy visit and collaborate in faith and hope.

This book is the story of the town of Louisville and its people, told in vignettes—snapshots—scraps of material culture that tell the tale of an almost-200-year-old city. This book is not a comprehensive or exhaustive history. There will be people and things that are left out that are part of Louisville's story. But there are only so many pages here, and there were only certain photographs, ephemera, and artifacts made available to us. It is our hope that the readers of this small tome will walk away with more knowledge than they had before reading our book and that they will be determined to tell the story and remember those who helped make Louisville what it is.

One

EARLY BEGINNINGS

When George Frederic Fainot (1802–1873) and Johann Heinrich "Henry" Lautzenheiser (1779–1849) laid out the town of Louisville in 1834, there had been people of European descent living in Nimishillen Township and in "Nimishillentown" for decades. Lautzenheiser was a Pennsylvania Dutchman from Westmoreland County, Pennsylvania, and belonged to the German Reformed Church. He settled north of present-day Louisville in 1807. Four years later, he bought land from his father-in-law near Harrisburg, and then he sold it in 1812. Fainot was born in Audincourt, France, and immigrated to America in 1828. His home was originally on the northwest corner of Routes 153 and 44, then later on 162 acres along Shilling and Nickel Plate Streets. He was a French Protestant and "an expert cradle maker and cabin builder," according to Kenneth R. Smith, author of *Louisville the Way It Was: 1834–1990*.

For decades, it has been believed that these two men chose the name Lewisville after Lautzenheiser's son Lewis. The story goes that in 1837, when they established the first post office, the postal service informed them that there was already a Lewisville in Monroe County, Ohio (established 1837). So, the founders changed the spelling to "Louisville." Adam Lautzenheiser (Henry's son) told the *Louisville Herald* (sometimes referred to simply as "the *Herald*") in an 1887 interview that the founders originally meant to memorialize the town's surveyor, Lewis Vail, in the town's name. One can find various forms of this fable regurgitated by local teachers and websites.

The plat book in the Stark County Court House tells a different story. In 1834, Lautzenheiser and Fainot recorded the name as "Louisville." Documentary evidence in the *Catholic Telegraph of Cincinnati* refers to the town as "Beechland" and "Louisville" in the July 1834 and September 1835 issues. It is clear that the town probably was named after Saint Louis, the patron saint of the local Catholic parish, which had been established prior to 1834.

In a time when Catholics and Protestants were segregated and different ethnic groups were insular, it is a mystery how Lautzenheiser and Fainot decided to collaborate other than for financial reasons. Developing land was lucrative.

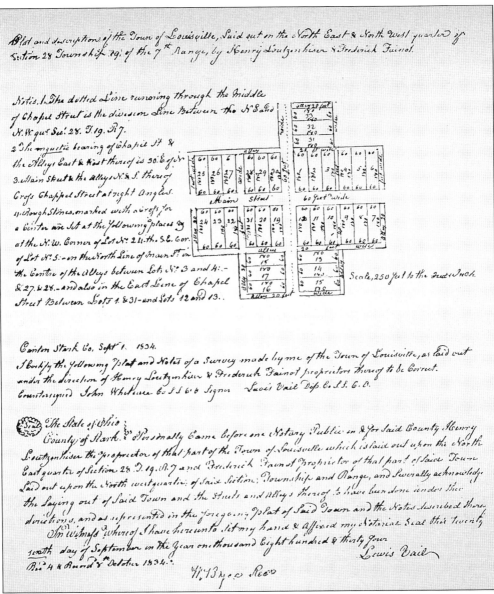

The plat record in the Stark County Court House bears the names of Louisville's founders, who filed it on September 1, 1834. This may well be the most important document in setting the record straight concerning the naming of the town. If Lautzenheiser and Fainot really wanted the town to be named after Lautzenheiser's son, Lewis, then this document would list the town's spelling as "Lewisville." Instead, the current spelling of the city is recorded in this document. It is interesting to note that at least one historian believed that the surveyor on the document was the "Lewis" in the tale. While Lautzenheiser and Fainot might have talked about naming the town after one of these Lewises, in the end, they chose a different spelling that honored the French saint Louis. This makes sense in light of the early Catholic presence in the town.

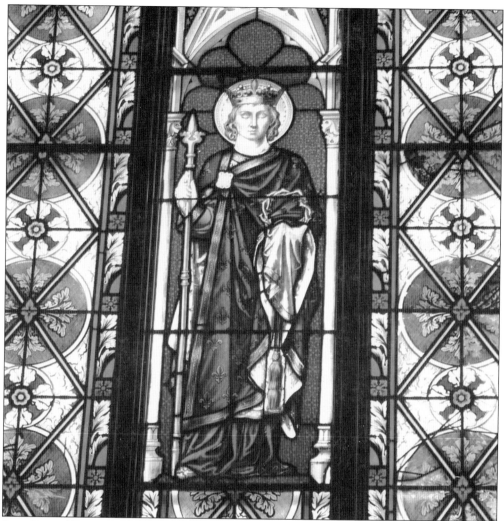

Saint Louis (1214–1270) reigned as the king of France (1226–1270) starting from the age of 12. Known for his reform of French law, he made his greatest mark as a defender of Catholic orthodoxy. He fought Islam in the Crusades and the Jews in France. He even burned the Talmud in 1240 at the Disputation of Paris, when 24 carriages full of Jewish religious manuscripts were set on fire in the streets of Paris. Yet he was a patron of the arts, particularly Gothic art and architecture, which became influential throughout Western Europe. In 1250, while he was participating in the Crusades, the Egyptians captured Louis, only to release him after receiving ransom money. Eventually, he succumbed to dysentery, as did many French soldiers in the Eighth Crusade. Louis is known for serving meals to the poor in his residence, often with his own hands, something that was unusual for royalty at the time. He was canonized as a saint by Pope Boniface VIII in 1297. This vignette is from the larger Victorian window in Saint Louis Church (behind the altar). (Photograph by Justus Grimminger.)

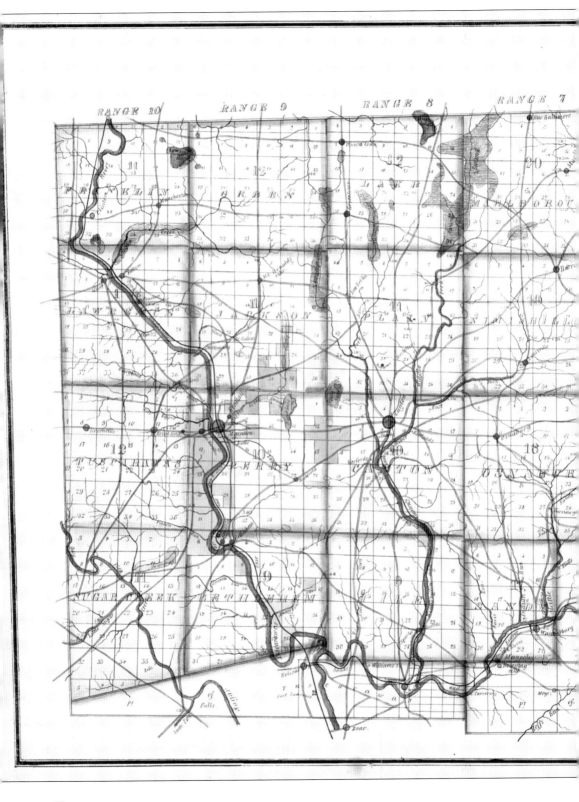

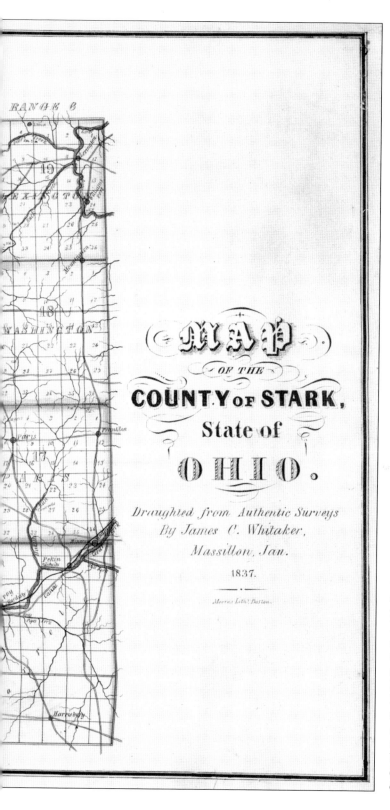

MAP
OF THE
COUNTY OF STARK,
State of
OHIO.

Draughted from Authentic Surveys
By James C. Whitaker,
Massillon, Jan.
1837.

Moores Lith. Boston.

James C. Witaker drafted this early map of Stark County in January 1837. Notice that Witaker spelled Louisville as it is currently spelled. This is another proof that Lautzenheiser and Fainot never changed the spelling of the town. During 1837, the Monroe County town of Lewisville, Ohio, was established, and the drafter of this map would have likely never known about the obscure Southern Ohio village that has long been thought in to be the reason for a spelling change in the name of Stark County's Louisville. This map shows the past prosperity of Stark County villages such as Paris, Osnaburg, Harrisburg, and New Franklin. These locales are now void of hustle and bustle, but in 1837, they were as big as or bigger than Louisville. (Courtesy of the Grimminger Collection.)

13

In the German church records of the Reformed and Lutheran Union Church at Paris, Stark County, Ohio, Henry Lautzenheiser appears in several places. Many German churches in Stark County once kept a record of pastoral acts and finances in ledgers like this one. The script handwriting was unique among the Germans and was still taught in Germany until Hitler outlawed it. This image shows an entry in the Paris *Kirchenbuch* (church book) that records Lautzenheiser and his wife as the parents and godparents for Katharina Lautzenheiser, born on April 12, 1829, and baptized by Lutheran pastor Wilhelm Schmidt on October 31, 1829. Schmidt went on to establish a Lutheran seminary in Canton at the corner of Tuscarawas and Cherry Streets. The seminary later relocated to Columbus as Capital University and Trinity Lutheran Seminary.

The Union Church in Paris, Ohio, originally held worship in a log structure, which also served as a parochial schoolhouse. In 1848, as America experienced its largest German immigration, the joint congregation started taking subscriptions for a brick building. These two leaves from the church's 1829 *Kirchenbuch* list some subscribers affiliated with Louisville: John Julliard (No. 2) who pledged $5, Henry Lautzenheiser (No. 130), who pledged $10, and others, including Peter Folk (No. 14/17), George Sponseller (No. 106), and Abraham Lutz (No. 10). German church treasurers usually used loose leaves as sign-up sheets and would dispose of them once the sums were recorded and the subscribers had paid. The fact that these subscriptions were preserved permanently in the church book with baptisms is a testament to just how important this record was to that church.

No.	Name	$	Cent
1.	Peter Rauch	20	00
2.	John Julliard	5	00
3.	Friedrich Wengert	4	50
4.	Jacob Dalman	4	50
5.	John Herbster	4	50
6.	Elisabeth Herbster	6	00
7.	Jacob Herbster	30	00
8.	Rebecca Bair	2	00
9.	Conrad Baber	11	00
10.	Abraham Lutz	23	00
11.	Jacob Herbster Jr.	2	25
12.	Christian Sommer	5	00
13.	Jacob Sommer	1	00
14.	Peter Folk Jr.	3	50
15.	John Gring	3	00
16.	Michael Sebrist	3	00
17.	Peter Folk	7	00
18.	Jacob Mox	15	00
19.	Samuel Shidler	5	00
20.	Edward Marsh	2	00
21.	George Reisle	1	00
22.	David Gabel	2	50
23.	Jacob Smith	2	00
24.	Sara Smith	1	00
25.	Donald Smith	4	00
26.	David Shidler	5	00
27.	John Smith		

No.	Name	$	Cent
105.	Peter Wengert	21	00
106.	George Sponseller	65	00
107.	Peter Freed	16	00
108.	Jacob Thoma	14	00
109.	Samuel Rauch	10	00
110.	William Oyster	14	00
111.	William Oyster Jr.	2	00
112.	John Honem	2	00
113.	John Fischel	2	00
114.	Abraham Klopfenstein	8	00
115.	George Coblentz	13	00
116.	Elisabeth Bair	16	00
117.	Michael Black	3	00
118.	John Bair	12	50
119.	Patrick Mallon	2	00
120.	Christian Zennenger	14	00
121.	Christian Regnas	16	00
122.	Jacob oyung	10	50
123.	Isaac Hains sr.	12	00
124.	Isaac Hains Jr.	5	50
125.	Benjamen Crisman	10	00
126.	Henry Wartman	4	00
127.	Isaac Burget	2	50
128.	Henry Freund sr.	1	50
129.	Peter Conrad	13	00
130.	Henry Lautzenheiser	10	00
		505	00

The lore behind the naming of Louisville involves Lewis Lautzenheiser (January 25, 1823–July 26, 1900), one of Henry Lautzenheiser's 25 children. This charcoal portrait of Lewis captures the man after whom many still believe the town was originally named. Anna Mary (Folk) Lautzenheiser (April 21, 1830–December 24, 1914) was Lewis's second wife. Lewis and Anna Mary resided on the Folk farm east of Louisville. They are buried in Union Cemetery, just east of town. It is interesting to note that the *Kirchenbuch* at Paris, Stark County, lists a "Louis" Lautzenheiser, which is likely a misspelling, as the Pennsylvania Dutch often spelled names as they sounded or believed that they were to be spelled.

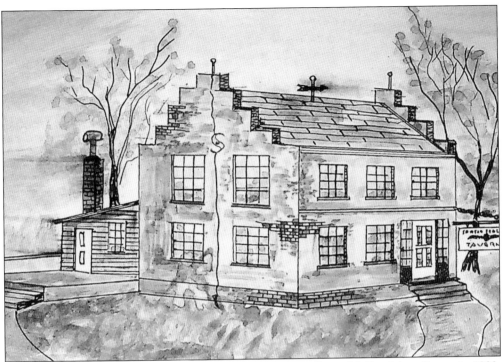

Henry Lautzenheiser built the Spread Eagle Tavern, originally at 513 East Main Street, in 1822. It was the first commercial building in Louisville. Lautzenheiser owned it until 1835, when the property was sold to Peter and Susanna Eck. The artistic rendering of the building shown here is undated and unsigned.

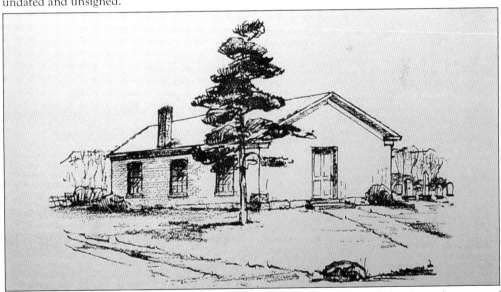

The French Baptiste Church (near the intersection of East Main and Nickel Plate Streets) was one of the first church buildings in Louisville. It is believed that a number of early parishioners at Paradise United Church of Christ attended services here before they organized their own congregation and built a building of their own. It was here where the first Sunday school in Louisville was organized and conducted.

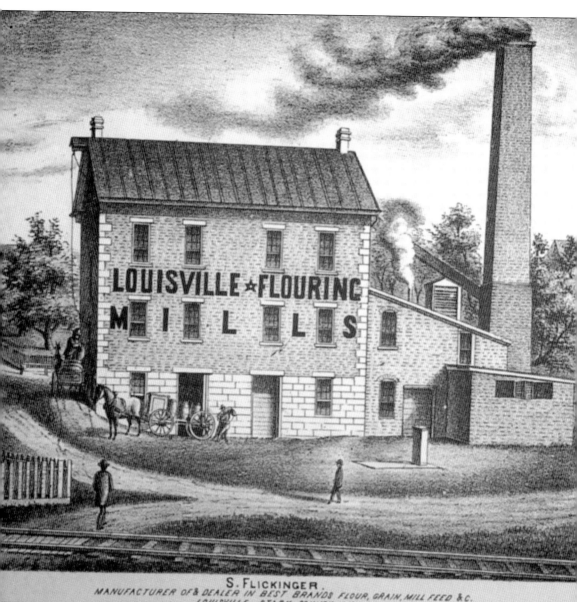

S. FLICKINGER
MANUFACTURER OF & DEALER IN BEST BRANDS FLOUR, GRAIN, MILL FEED &C.
LOUISVILLE, STARK COUNTY, OHIO.

Star Mills is likely the oldest business in continuous operation in Louisville. It was established in 1851 by Daniel Chappius. Later, Louis Faber, Xavier Paumier, Simon Flickinger, and C.A. Newhouse operated this mill. In 1881, people knew this business as the Louisville Star Flouring Mill. The building, however, is believed to date back to 1848, the time of the greatest emigration from Germany, which helped to promote agricultural life and the need for this mill. From 1848 to 1849, Germans emigrated after the revolution failed to secure democracy in the fatherland. This immigrant population grew in America from 5,308,483 to 45 million in the period from 1800 to 1875. The mill's redbrick structure is reminiscent of the Germanic architecture of Pennsylvania, an aesthetic that would have appealed to the German-speaking people of Louisville and the surrounding township. This engraving was included in the *Atlas of Stark County, Ohio*, by William and Orrin Kauffman.

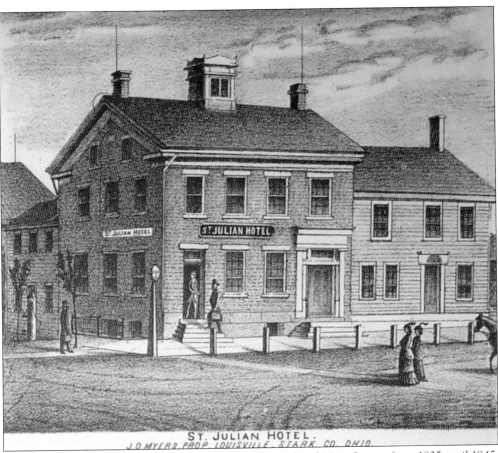

ST. JULIAN HOTEL.
J.O. MYERS, PROP. LOUISVILLE, STARK CO. OHIO.

The Wolfe Hotel occupied the northeast corner of Chapel and Main Streets from 1835 until 1845. Joseph Vignos built the current building in 1848 as the Union Hotel. Later, it would be the St. Julian Hotel, Myers Brothers Hardware, Lesh House, J.J. Moinet Grocery, and Commercial House. The bricks in the original walls came from local clay and were likely made by Henry Lautzenheiser, who was the earliest manufacturer of brick in the area. In 1921, the building was remodeled and improved. Today, new brick facing and copper accouterments dress up the building, but the date stone high on the west wall informs that this is one of the earliest buildings still standing in the city. (Above, from the *Atlas of Stark County, Ohio*; below, photograph by Justus Grimminger.)

Historian John Lehman wrote in his *A Standard History of Stark County* that at the time of his death (June 5, 1849), Henry Lautzenheiser was "the most prolific father who ever lived within the bounds of Stark County," having fathered 25 children. His mortal remains are in the cemetery at Paris, Stark County, Ohio. Someone removed his tombstone from the grave, which is now unmarked. After clearing 200 acres in Nimishillen Township and 800 acres in Indiana, Frederic Fainot died, and his children buried him and his wife, Marguarite (Rayot) Fainot, in the Linton, Indiana, cemetery. The tombstone scrivener misspelled Frederic's first name as "Frederick." Worse yet, John Danner's *Old Landmarks of Canton and Stark County, Ohio* (1904) mistakenly called Frederic "Frederick Kaint." (Below, drawing by Julia Grimminger)

Two

SAINT LOUIS CHURCH

Saint Louis Roman Catholic Church is the oldest church in Louisville. "The strongest element of the congregation was French . . . from Alsace-Lorraine [which immigrated] ten years before and settled Northeast of the site of Louisville, at that time unplatted," according to John H. Lehman, author of *A Standard History of Stark County*, vol. II. The Irish Carroll family came in 1811, followed by the Moffitt and Devinney families in 1822. Before 1846, the parish "consisted of about twenty German families and twelve Irish," wrote Lehman.

Originally, Catholics in the township traveled eight miles to Saint John's Church in Canton, and the missionary priests of that parish would come to celebrate Mass in the homes of the Eck, Menegay, Frantz, Moffitt, and Myers families. Indeed, sacramental acts from 1830 to 1834 are recorded in the Saint John's parish register for Nimishillen Catholics. In the year of Louisville's founding, there were 240 Catholic communicants, and the bishop expressed his wish for a church building to be completed by the winter of 1835.

By the spring of 1836, the shell of the new Colonial-style church was erected, and in February 1838, Fr. Matthias Wuerz was installed as the first resident priest. While this land was donated to the parish by Henry Lautzenheiser, Frederic Fainot donated land across the street upon which a log rectory stood. Later in the 19th century, a convent, college, parochial school, orphanage, and nursing home were established on this property.

Possibly the most significant priest to serve the parish in terms of legacy was Fr. Louis Hoffer. Under his direction as the pastor and "master builder," Saint Louis Church razed the first building in 1869 and built its impressive French Gothic edifice. With its ornate high altar, pillars fashioned from solid tree trunks, intricately carved capitals, and vaulted ceilings, the parish could boast of a house of worship that was on par with European cathedrals.

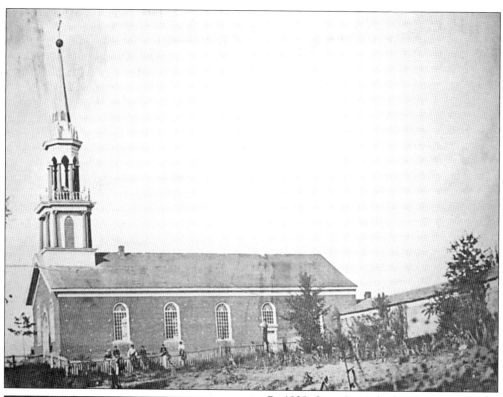

By 1838, Saint Louis had gathered materials to build the first church house and built it quickly, completing it in 1838. The congregation's history states the building had "a graceful and well-designed wren tower . . . built to adorn its rather low roof." The 30-foot-by-40-foot building was originally unplastered inside.

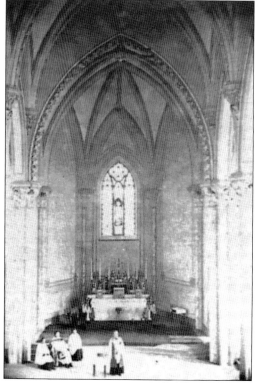

This is the earliest known photograph of the interior of the second church building, which still stands. Frank Walsh, a Cleveland architect, designed the space. As has been the case in the history of Christianity, the high altar was on the east wall so that priests and people would celebrate Mass *ad orientem* (toward the east). The window depicting the parish's patron saint, Louis, beams brightly above, illuminating the apse.

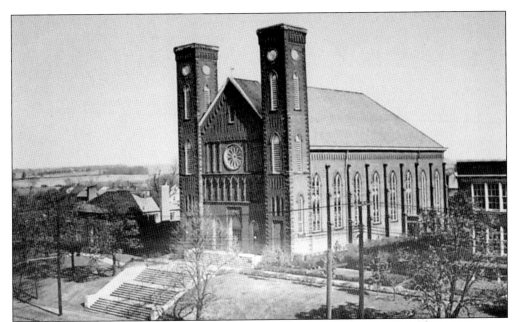

The first building was razed in 1869 to make space for this French Gothic edifice. Fr. Louis Hoffer, who served this parish between 1861 and 1897 and was educated and ordained in France, "drew the plans for the exterior shell after a model in France," according to the parish history. Between tithes from France, local subscriptions, and generous gifts from Father Hoffer's Cleveland friends, the parish had the $31,000 to build.

Eventually, the chancel space around the altar was lavishly adorned to reflect the beauty of heaven. This was in keeping with the theology of the church and the belief that Jesus is present in the Eucharist. After the Second Vatican Council (1962–1965), Saint Louis Church changed the chancel, stripping it of its iconography and high altar.

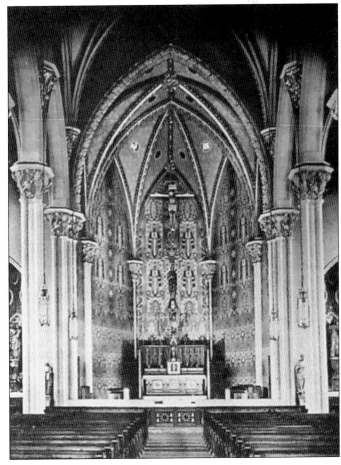

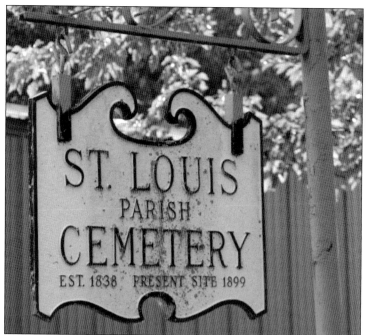

A cemetery accompanied the original church building (1838), but it was later relocated (1899) to Ravenna Avenue, going south out of town. Parishioners, priests, and nuns are among those who rest here, including Msgr. Robert D. Delmege, who was Saint Louis's pastor from 1954 to 1968. Each section of the new cemetery bears the name of a saint, and a chapel provides beauty and shelter for grave-side services.

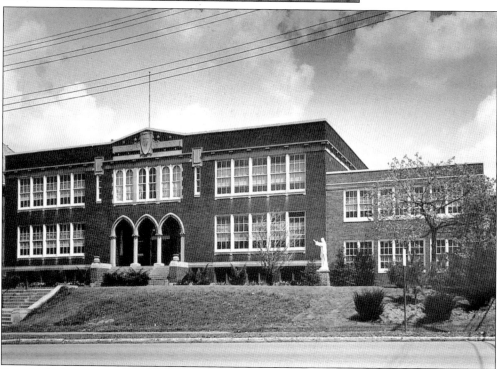

Parochial education was a priority from the earliest period of the congregation's history. In the 1850s, Fr. L.F. D'Arcy led the parish in building a schoolhouse and greatly improved the grounds around the church. The year 1922 saw the building of a new public high school building and a new parochial school building, pictured here. The diocese closed the Saint Louis school permanently at the close of the 2018–2019 school year.

Fr. Louis Hoffer (1824–1897) is possibly the priest that Saint Louis Church remembers most, since his time in Louisville was prosperous. He led the parish in building the academy and college building across the street from the church (where the McDonald's is now), and he designed and oversaw the construction of the French Gothic building that the parish still worships in today.

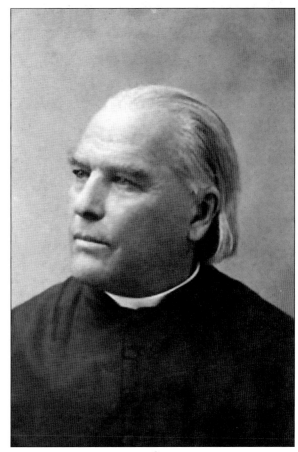

Saint Louis Church used this building across from the church to operate multiple agencies, including a college and orphanage. Cofounder of Louisville George Frederic Fainot gave this lot to the church originally so that a small log rectory could be built. The church's history states that it was "neither weatherboarded nor plastered inside . . . [but it was] sufficiently comfortable for a missionary."

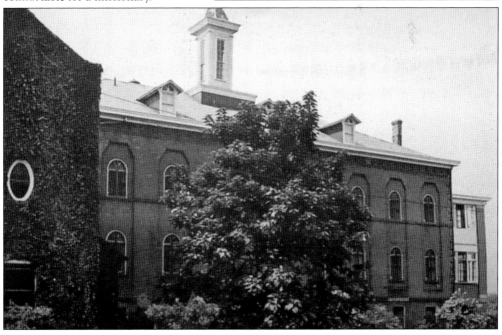

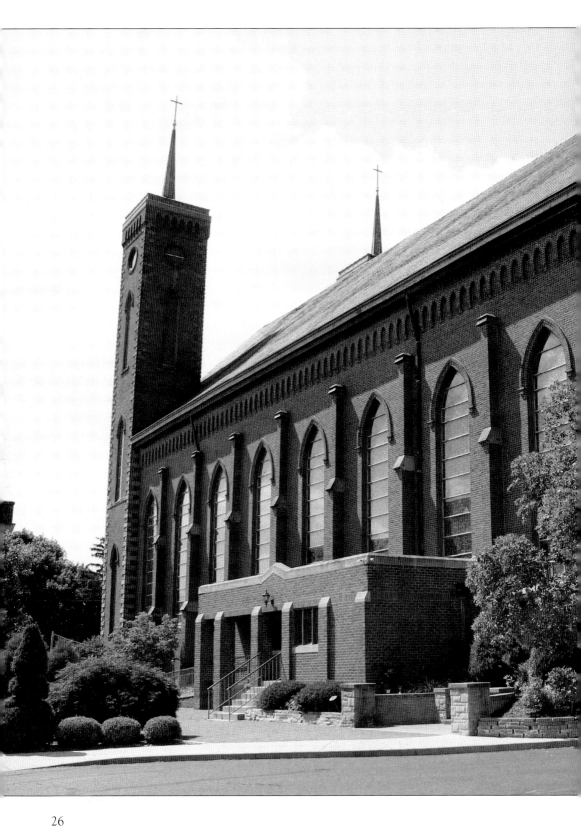

This rear-view photograph by Justus Grimminger illustrates the sheer size of the Saint Louis Church building. Complete in 1875, it is reminiscent of French Gothic cathedrals and churches. The decorative brickwork below the spouting would have been appealing to Victorians as would the diverse shapes in the Saint Louis window on the east wall. It is hard to imagine how difficult it was to transport the foundation stone by ox cart and how labor-intensive it was to produce enough brick. The parish produced its own brick in church-owned kilns located at the intersections of East Gorgas, East Main, and Silver Streets. Buttresses support the north, south, and east walls. The bell towers rise 125 feet into the sky. The south tower holds a bell cast in France that made its way to Louisville by way of Steubenville.

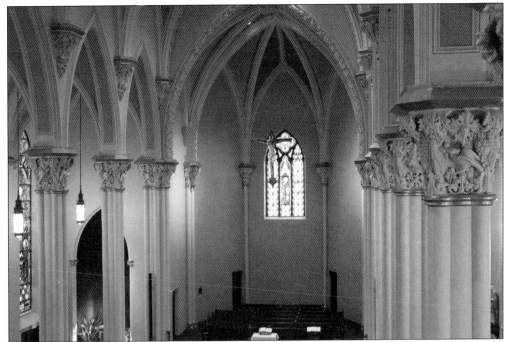

The vaulted ceiling in Saint Louis Church hangs 67 feet overhead, supported by pillars that are fashioned from solid tree trunks. Those trees "were carefully selected and donated from the woodlands of parishioners," according to the parish history. Like a French cathedral, the worship space in Saint Louis is supposed to inspire awe and direct attention to the magnitude and mystery of God. The sturdy appearance of the columns on each side of the nave gives worshippers a sense of stability and security as they attend Mass. A recent paint job restored color to the ceiling and added gold on top of and below each capital. (Photographs by Justus Grimminger.)

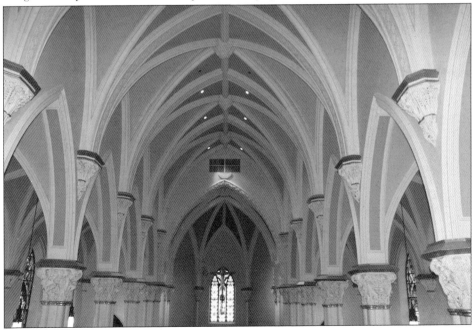

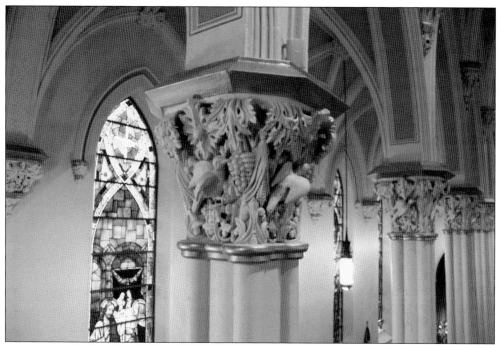

Capitals sit on the top of columns and bring the ceiling and pillars together. They also help to direct the gaze of the viewer up toward heaven. These capitals are particularly special as the stone carver created doves, ravens, ears of corn, fleur-de-lis, and leaves out of stone. There are few things as beautiful except for maybe the sound of a historic pipe organ. The organ is perched high up on the balcony, as is the tradition in Europe. This placement allows for the sound to wash over the congregation below, and it maximizes the space below in the nave for gathering and worshipping. A rose window is in the west wall behind the organ. (Photographs by Justus Grimminger.)

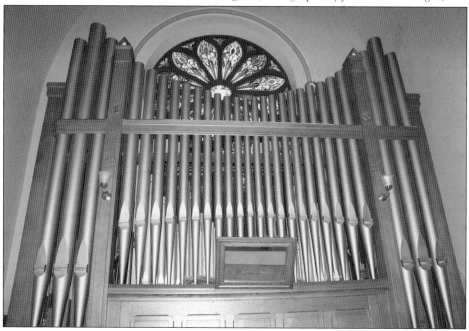

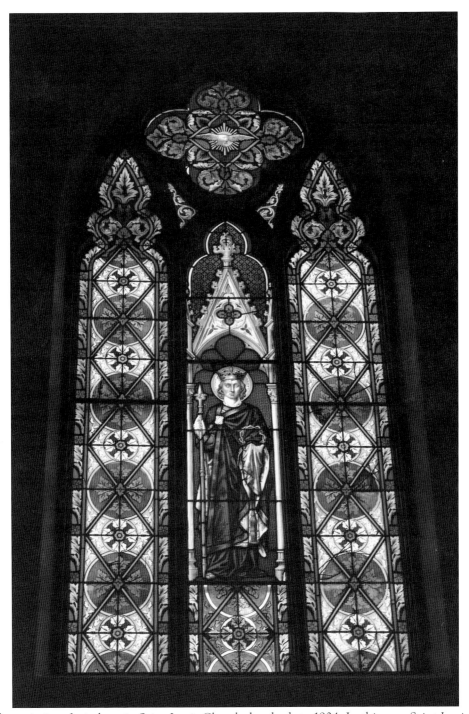

The majority of windows in Saint Louis Church date back to 1904. In this way, Saint Louis is also similar to European cathedrals, where there is constant renovating and additions of modern elements to the old. The only original window that remains is the Saint Louis window high in the chancel area at the front of the church. Amazingly, until recently, this window had been covered with plaster and brick and long forgotten. (Photograph by Justus Grimminger.)

Three

PARADISE
REFORMED CHURCH

Unlike other towns in Ohio and Pennsylvania, Louisville had a German Reformed presence but no Lutheran church for decades. Usually, the two confessions shared a church building as a "union church" because they spoke the same language and had similar theology. This was true in many other nearby towns, including Osnaburg, Paris, Canton, Alliance, Navarre, New Berlin, and others. The Reformed came from the branch of the Reformation that followed the theological teachings of John Calvin.

German Reformed people in Nimishillen Township established the German Reformed Church in 1863 under the direction of Rev. Abram Miller. Before this, these Pennsylvania Dutch–speaking people worshiped in one another's homes. It appears that they also worshiped in the French Baptist church building for a time before establishing an official congregation. In 1867, when the Baptist congregation waned, the Reformed bought the Baptists' building and their cemetery on Washington Street.

For a number of years, this Reformed church was yoked with the Reformed churches in Paris and Osnaburg. Further, through Pastor Leberman's efforts, Reformed churches were established at Robertsville in 1875 and Maximo in 1884. The congregation eventually signaled to the world that it was assimilating into the Anglo culture around it by removing the word "German" from its name. The name "Paradise" was not used until 1924. Eventually, the congregation's denomination became the United Church of Christ in 1957, and this congregation changed its name to Paradise United Church of Christ in 1962.

In recent years, the congregation obtained lots around the church building (1958 and 1997) to build on and add parking. More recently, the church was renovated to establish a preschool within its walls. Under the pastorate of Rev. Dr. Kline Roberts III, who served Paradise from 1994 to 2008, the congregation developed a new image and renewed mission that reached out into the community. Today, it remains one of the larger Christian churches in Louisville.

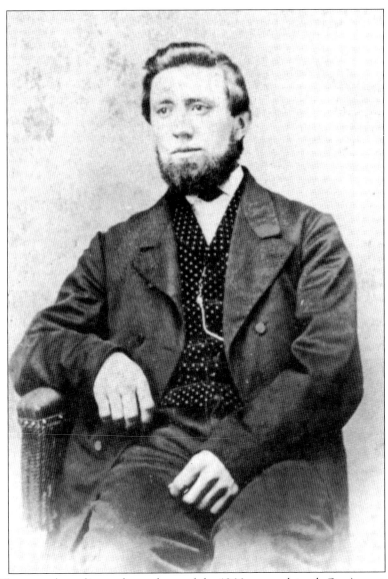

Abram Miller started as a licensed preacher and, by 1866, was ordained. On August 6, 1862, he led the Reformed at Louisville in their first liturgy. The next year, on November 21, the charter members met with him to establish the congregation officially. Not only was it difficult to start a church, but the people were "preoccupied with fear and anxiety" because of the Civil War (1861–1865), according to H. Jay Shoemaker, author of *History of Paradise Church*. "Already two of Johnathan Slusser's sons had been killed in battle and five other church families had sons off fighting in the war," wrote Allen E. Gress in *Paradise United Church of Christ: One Hundred Fifty Years in the Service of Christ 1863–2013*. Miller, being a Pennsylvania Dutchman himself, was able to preach in high German (Hochdeutsch) and English; he could speak Pennsylvania Dutch (Deitsch) also. When he left Louisville, he served the Lake Township charge of Reformed congregations and moved to Uniontown, Ohio. If this is the same Rev. Abram Miller who served the Lutherans at North Georgetown, Ohio, he was born on February 25, 1838, and graduated from Heidelberg College in 1863 after enlisting to fight in the war and being honorably discharged. (Courtesy of the Paradise Church Collection.)

The earliest parish register begins with a beautifully lettered title page in black and red reminiscent of the beautiful title pages one can find in the German theological books of the 16th and 17th centuries. The records begin with the list of charter members, and this volume holds the earliest records of the parish. Interestingly enough, this book is entirely in the English language, showing that while some members preferred German in the worship service, pastors were already moving forward with assimilating these folks into the English-speaking culture around them. Other German Lutheran and Reformed churches in the area were still keeping German records at this point in time. The Lutheran and Reformed Union Church at Paris, Stark County, Ohio, continued with its German record keeping beyond the 1860s. Such parish registers were in danger after the world wars, when locals associated the German language with Germany and even Hitler. Churches like Saint Paul Reformed Church in Osnaburg lost their German records when church staff took them behind the church and burned them. (Courtesy of the Paradise Church Collection.)

The first few pages of records in the early parish register provide the names of the congregation's charter members. Many of the earliest Louisville names were not on this roster "for they previously had been absorbed into the older churches, the Catholic and United Brethren. The leaders and early church members were recruited mostly from the farmers, artisans, and laborers," according to H. Jay Shoemaker. (Courtesy of the Paradise Church Collection.)

Rev. Joshua Horlocker Derr (1822–1891) served in Louisville from 1869 to 1872. He was born in Lehigh County, Pennsylvania, and attended Franklin and Marshall College. "He was a forceful preacher . . . a good parliamentarian. . . . He was in demand at church dedications because of his ability to raise money and because he could speak equally well in either German or English," wrote Shoemaker. (Courtesy of the Paradise Church Collection.)

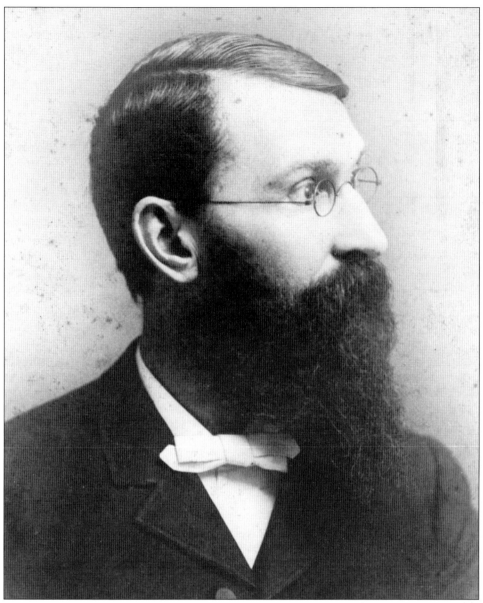

Rev. Dr. John J. Leberman served from 1872 to 1900 as the longest-serving pastor of the Paradise Church in the 19th century. His father immigrated from Bavaria to Lebanon County, Pennsylvania, in 1837, and John spent his formative years in Meadville, Pennsylvania. Young John attended a preparatory school, taking up the study of Latin, Greek, and German while working in the railroad office at Meadville. After graduating, he attended Heidelberg College, where he earned his bachelor and seminary degrees. His first call was in Louisville, where he quickly became an important part of the community. Shoemaker wrote that Leberman had a "commanding presence in the pulpit . . . with an earnest and entreating facial expression and a ringing tone of eloquence . . . [which] materially contributed to the success of his every sermon." While at Louisville, Leberman preached at Paris and Osnaburg, and he started the Reformed churches at Robertsville and Maximo. Leberman's friendship with Father Hoffer at Saint Louis Church was a monumental relationship that influenced Reformed and Catholics alike. (Courtesy of the Paradise Church Collection.)

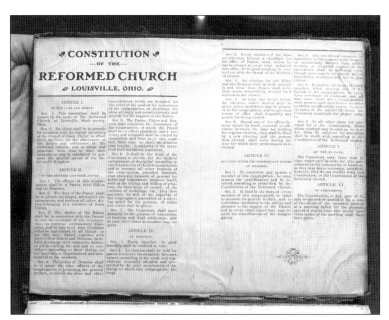

As a quick reference, the constitution of the church was pasted inside the front board of one of the earliest parish registers. It is likely that each parishioner had their own copy that a local printer printed for the church. This was the governing document of all of the church's business. (Courtesy of the Paradise Church Collection.)

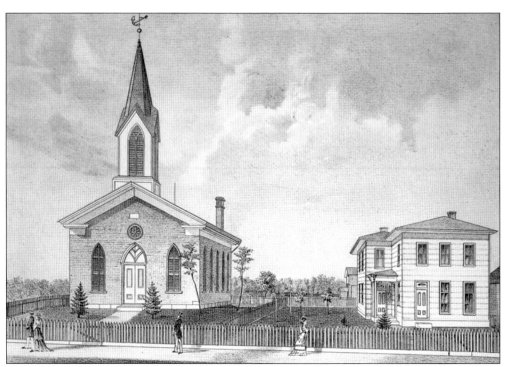

Shoemaker wrote, "The [1869] church . . . was lighted with oil lamps. Its heating facilities consisted originally of two wood burning stoves, one along the east and one along the west wall half way between the front and rear. . . . During cold weather people seated near the stoves and those in the balcony overhanging the south entrance area roasted while those in other parts shivered." (Engraving from *Atlas of Stark County, Ohio*.)

Theodore Romy built this model in the 1920s of the original Reformed church building, which was completed in 1869. The brick edifice was the Reformed congregation's house of worship from 1869 until it was razed to build a new brick church in 1893. The model is on display in the main exhibit room of the Louisville-Nimishillen Historical Society.

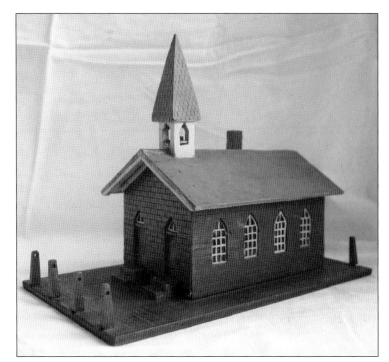

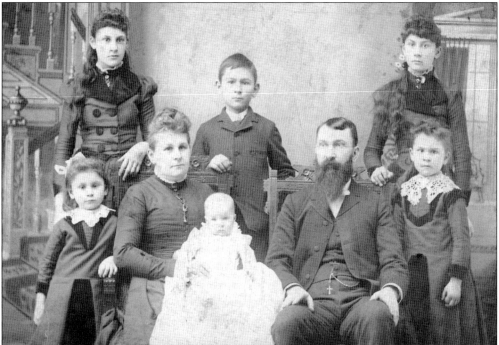

During his 17 years as pastor at Louisville (1872–1900), Rev. John J. Leberman (1845–1921) got married and had nine children. His wife, Elizabeth Lutz (1851–before 1910), was likely related to Abraham Lutz (who lived on Paris Avenue) and his progeny. Zeiger Studio captured this family portrait in about 1901. On the back of the photograph are names, but the order of the children (Louise, John, Esther, Agnes, and Evelyn) is not certain.

A POPULAR TREATISE

ON

BAPTISM.

IN THREE PARTS:

What is Baptism?

Who is to be Baptized?

How are we to be Baptized?

BY

REV. J. J. LEBERMAN, A. M.

DAYTON, OHIO :
REFORMED PUBLISHING COMPANY,
1886.

Pastor John J. Leberman brought a new approach to ministry at Paradise Reformed Church. He was more than a pastor—he was also a scholar. This is the title page of his 1886 book on holy baptism. In it, Leberman clearly expresses the historic Reformed view on how baptism should be administered: "Let the testimony so certain and conclusive, both from the inspired Word of God and of church history, be sufficient to bring all to the adoption of that manner of baptism most expressive of the purification of the soul from sin by the blood of Christ, which the apostle affirms is applied by sprinkling. Kings, priests, and prophets were anointed by pouring or sprinkling. The people of God are called the anointed, having received both the pouring out of the Spirit and the sprinkling of water." The publisher eventually issued a second edition of the book. (Courtesy of the Grimminger Collection.)

Paradise Reformed Church, Louisville, Ohio

The year 1893 was an important one: a new brick edifice was completed on the site of the 1869 building. The cost of the new church was $10,610. Some "judged [the new building] to be the finest outside of big cities," according to church historian H. Jay Shoemaker. The crown jewel of the brick structure was a large rose window, which Jonas and Ann Spangler donated. They lived across the street from the church and would see it every day when they looked out of their home. The altar originally found its place on the north wall of the worship space, later moving to the south wall, changing the orientation of the worshippers so that they were facing the rose window during liturgies. The small round window in the belfry was installed in memory of Rev. John J. Leberman's daughter May. (Below, photograph by Justus Grimminger.)

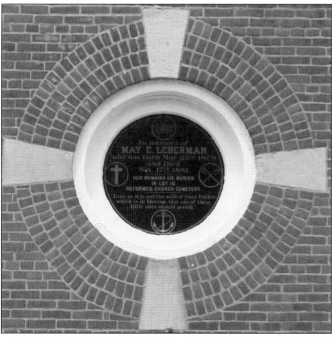

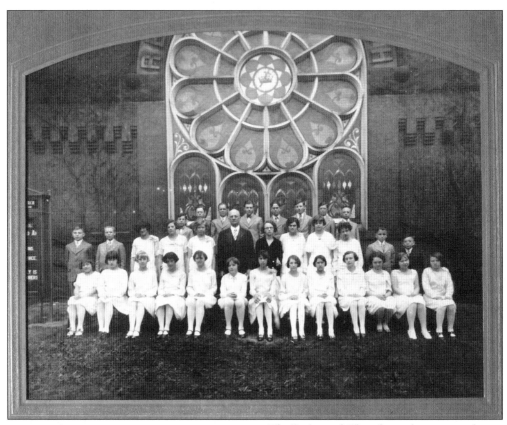

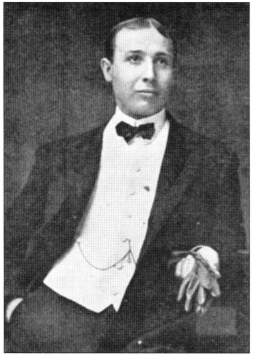

The Reformed Church saw baptism as the beginning of the Christian life. This was followed by catechism class, when the young studied the *Heidelberg Catechism*, and the rite of confirmation, when one became a full member of the church and could vote in meetings. The first Reformed confirmation class in Louisville was confirmed on April 8, 1864. This photograph shows the sizable 1937 confirmation class. (Courtesy of the Paradise Church Collection.)

Rev. Dr. Blanchard Allen Black (1873–1942) was chosen from 17 applicants for the vacant pastoral call in 1908. He stayed until 1914. During those years, financial issues persisted, and there was a high turnover in choir directors. The church hosted temperance events, and Black established the first Boy Scout troop. Black helped relocate a controversial hitching post from in front of the church. (Courtesy of the Paradise Church Collection.)

This rare view of the nave and chancel was taken before 1959. Like many Reformed churches before the liturgical revival in American Protestantism, the pastor wore a black preaching robe, the pulpit had a higher elevation than the altar, and the choir sat facing the congregation. It is curious that the altar was on the north end of the worship space instead of the traditional position on an east wall. Paraments on the altar and pulpit, along with the brass cross and candlesticks, gave a traditional Protestant look to the altar area. A railing stood between the altar and the congregation, fencing off the altar so that the people could kneel to receive Holy Communion. The solid wooden paneling that rose above the backs of the choir members worked together with the crown molding high overhead and the stenciled (or papered?) wall to give the worship space a simple elegance. (Courtesy of the Paradise Church Collection.)

A 1955 facilities study led to a renovation of the 1893 brick building and a new addition that extended eastward from the church. Under the guidance of Rev. Robert Keiser, a native of Sharon, Pennsylvania, who served Paradise Church from 1955 to 1984, the new facilities were completed in 1959. The total cost was $23,000 to acquire lots, $329,650 for the actual construction, and $25,000 for furnishings and equipment. While the parsonage built in 1870 had to be razed, the church now had expanded facilities for education, recreation, socializing, and music making. The congregation would not renovate or add to the church building again until 2000 under the leadership of Pastor Kline Roberts, pictured here. (Both, courtesy of the Paradise Church Collection.)

Four

OTHER CHURCHES

Louisville's earliest Protestant inhabitants were mostly French Baptists or "Dunkards." In his 1904 county history, John Danner notes that the first preacher "in the neighborhood was John Gans, a Tunker [*sic*]. It was the custom of his denomination to hold worship in barns." In 1851, Fainot gave one-third of an acre for the building of a German Baptist church building, but there is no record that the project ever came to fruition.

Mennonites, who would have shared Pennsylvania Dutch foodways, language, music, and other culture with the German Reformed folks, came early onto the scene. The Beech Mennonite Church (also known as Buchenland or Beechland), just outside of Louisville, used to be Amish. It was established by Swiss and Alsatian immigrants in 1825. About five years later, it built a log church on Paris Avenue. Later, it relocated farther north on Paris Avenue. Stoner Heights Mennonite Church (now Theophilus Bible Church) was established in the 1950s, having Delvin Dale Nussbaum (1930–2012) as its first pastor.

Throughout the last 150 years, a number of Protestant congregations have sprung up in Louisville, both evangelical and Pentecostal. Brethren, Methodist, Assembly of God, Lutheran, Baptist, and independent churches remain a part of the religious fabric of Louisville, even today.

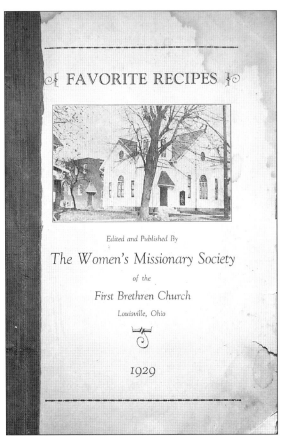

FAVORITE RECIPES

Edited and Published By

The Women's Missionary Society

of the

First Brethren Church

Louisville, Ohio

1929

In 1929, the Women's Missionary Society of the First Brethren Church in Louisville published a cookbook. Among the cherished recipes of the book are Louisville business advertisements. A 1934 inscription inside this Grimminger Collection copy states that it was a gift to Marie Zumbrunen from Mr. and Mrs. Howard Snyder. It was passed down in the Zumbrunen family to Russell Newburn (1938–2017).

The First Brethren Church on East Main Street retains the original Victorian window framing. Today, the outside looks quite different than it originally did because the congregation added a sizable narthex onto the east side of the original structure. Recently, with the arrival of the new pastor came some fresh changes to the inside of the worship space.

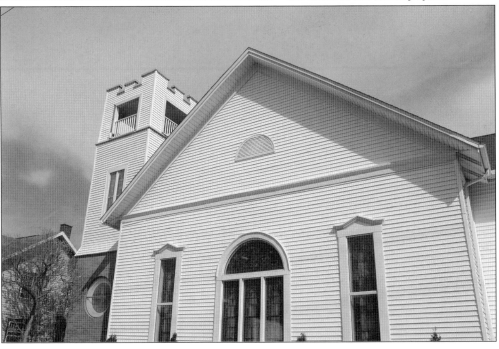

Saint Stephen Martyr Lutheran Church was Kountze Memorial Lutheran Church until November 2021, when Saint Stephen (Canton) assumed responsibility for Kountze. From 1843 until 1844, this congregation, which started in Osnaburg, bore the name United Evangelical Church. From 1844 to 1891, the church went by Trinity Lutheran Church. Augustus Kountze, the son of early members Margaret and Christian Kountze, paid to erect a new building in 1891 and named it after his parents. When the building burned in East Canton (1968), parishioners met in homes and then built this modern structure (completed in 1986). Because the congregation lacked "good, solid leadership," according to church council member Bridget Lindsmaier, the congregation declined, prompting the 2021 merger. Christian Kountze's tall tombstone towers over the original church steps in Osnaburg. (Photographs by Justus Grimminger.)

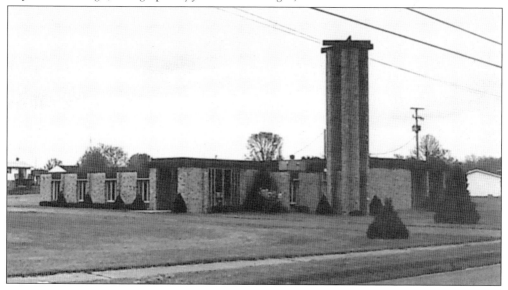

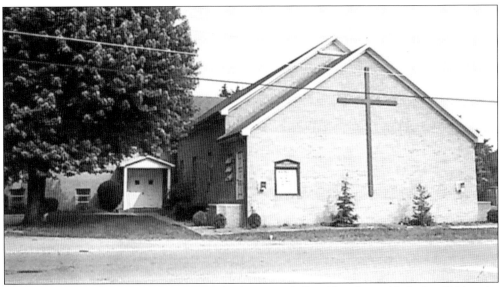

The Church of the Brethren traces its roots back to Nimishillen Church, established in 1804 as the first Church of the Brethren in Stark County. Center Church of the Brethren at Georgetown Road and Route 44 started in 1825 as the first church plant from the original Nimishillen congregation. After worshipping in barns and homes, the congregation built on the present site in 1868, completing the current building in 1959.

Christ United Methodist Church on Gorgas Street was originally First United Brethren Church, established in 1856 by Daniel Slusser, John Myers, Emanuel Schoop, John Shilling, and Rev. John Demming. The first building sat at the corner of Gorgas and Walnut Streets; the cemetery was situated along East Broad Street until it was removed in 1929. The current building was erected in 1901, and the current nave (sanctuary) was completed in 1960.

The First Assembly of God Church on West Main Street was established in 1928. For a while, the congregation worshipped in a small building on Washington Street. That building is now a residence. Throughout the last 30 years, Pastor Dan Deem has helped the congregation grow, and he led the church as it implemented a large building project.

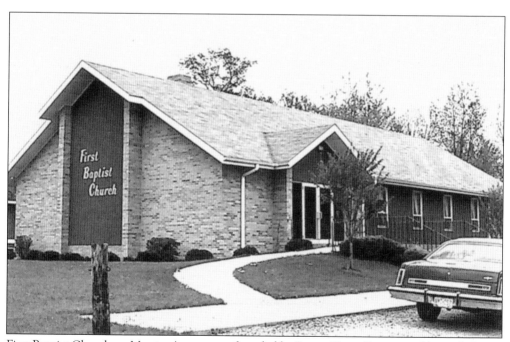

First Baptist Church on Monter Avenue was founded by Pastor Harry Ramsey and his wife, Joyce. The current lead pastor, Greg Summerfield, was born and raised in Louisville. He and his wife, Sarah, and the associate pastor, Ron Mayberry, and his wife, Kathy, serve this congregation and make it a welcome place. The only other Baptist church close to Louisville is Louisville Baptist Temple (established in 1957) on Columbus Road.

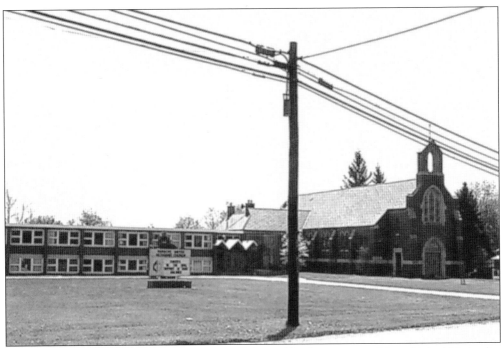

Fairhope United Methodist Church on Louisville Street Northeast is one of three United Methodist congregations in Louisville today. Architectural elements of the worship space and exterior structure remind the worshipper of Methodism's Anglican roots. The stained-glass windows are particularly notable and worth viewing on a bright day from inside the nave.

The Community Bible Church is located on Monter Avenue. Other independent Louisville churches like the Louisville Christian Church and the Berean Bible Church look very similar in the humble styles employed and the simple materials used. This is a plain church house that is reminiscent of the simplicity of 19th-century American Protestant churches.

Peace United Methodist Church on Ravenna Avenue began in 1957 at the home of Mahlon and Euphemia Miller. For a while, this congregation held services above the Isaly's store in downtown Louisville. Rev. James Heckathorne, who was the pastor in New Franklin, came to Louisville to lead the earliest liturgies and preach. In 1959, the land was purchased, and the current building was completed in stages from 1960 through 1995.

Stoner Heights Mennonite Church, now named Theophilus Bible Church, was established on Stoner Road in the 1950s. Its first pastor was Delvin Dale Nussbaum (1930–2012), a graduate of Goshen College. Its exterior design and date stone reflect the time it was built and a humility that is rare in modern church buildings. (Photograph by Justus Grimminger.)

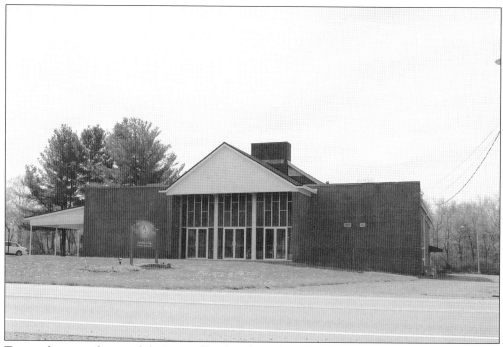

Twenty-three people started the Louisville Church of Christ on January 3, 1954. Their first worship space was rented above the Isaly's store (now Uptown Joe coffee shop) in downtown Louisville. The nucleus of the building in this photograph evolved from a basement in 1956, with later additions in 1961 and 1967.

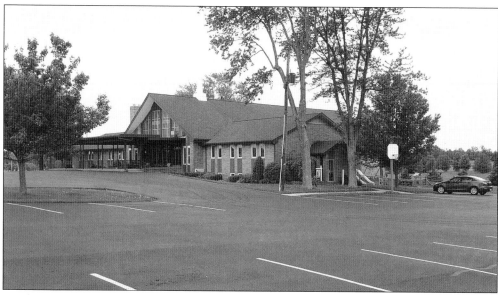

Beech Mennonite Church was originally called Buchenland. The original log structure sat close to where the original cemetery is still found today (on Paris Avenue, just south of Louisville Street, on the west side of the road). The current building, at the corner of Easton Street and Paris Avenue, is modern in style and very different from the first church house of 1830.

Five

BUSINESSES

One could spend years studying and creating a set of books devoted just to the topic of businesses in Louisville.

It is no secret that drinking establishments did big business in Louisville. In the May 20, 1869, issue of the *Ohio Repository*, this became clear. Even with a modest-sized population, Louisville had "one brewery and ten place[s] . . . where any one can buy and may have his stomach bitters, and a full supply of lager, etc." Ferdinand Brader's pencil drawing of the Dilger Brewery certainly confirms that there was a thriving brew culture and clientele in town at the time and this was lucrative. Outsiders knew Louisville as being a haven for hard-drinking people in the 19th century. This may be in part because of the heavy French and German population.

Another important industry for Louisville in its early years was clay and brick. The earliest kilns were owned and operated by Henry Lautzenheiser and then by his son Adam at the southwest corner of East Main and Silver Streets. By 1880, Louisville produced a huge number of bricks yearly. Merley and Company alone could turn out 14,000 common and 4,000 pressed bricks each day.

The WPA painting by Herschel Levit (1912–1986) in the Louisville Post Office reminds visitors in its title, *Farm and Mill*, and in its artistic content that agriculture and steel were also major players in Louisville's economy. Dairy farms provided many jobs for Louisvillians both on the farm and in cheese factories and stores that sold dairy products. In 1922, the Superior Steel Company boasted of employing 800 men. This was just one of a number of steel companies to have an operation in Louisville over the years.

Downtown Louisville was a hub for thriving family-run businesses, from jewelry stores to bakeries, to shoe stores, and just about anything else one could need or want. The town could support multiple grocery stores and meat shops simultaneously. Louisville was thriving.

In 1875, H.W. Wertenberger opened his clothing store in Louisville, and soon after, his sons joined him in the business. This followed Wertenberger's partnership with John Wertenberger and David Sluss in dry goods. In 1931, H.W.'s son Joseph sold the clothing store to Homer Kandel (Kandel Brothers), and then in 1971, Chuck Luenberger bought it (Chuck's). This advertising plate wished Wertenberger's customers good luck with a horseshoe.

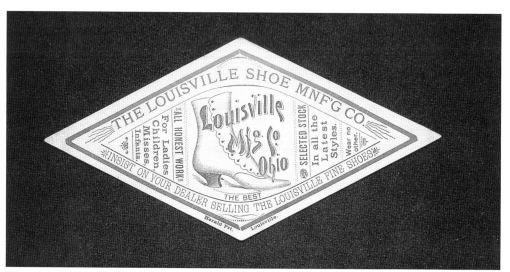

The ad for Louisville Shoe Manufacturing Company was originally meant to be disposed of after use, as it was a dye-cut paper ad. This company was likely the only shoe company to ever produce shoes in Louisville. It began production soon after its factory opened. It produced shoes for children, infants, and women.

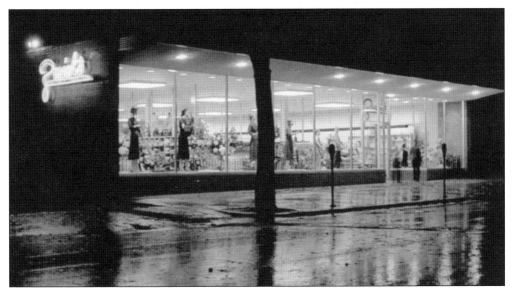

Zwick's general store started in 1926 in the town of Harrisburg, Ohio, but in 1932, Zwick's moved to Louisville as a dry goods store. Then in 1956, it opened the Zwick's Department Store on Main Street; it sold mainly women's and children's clothing. Unfortunately, the store closed in the early 1990s.

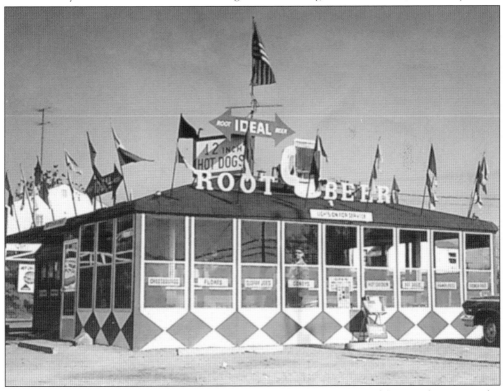

This 1964 image of the Root Beer Stand, located on West Main Street (close to the present-day Circle K store), is one of the only pictures of this business. Dick Walker had the building razed and constructed a new building that would house the Walker Restaurant starting in 1971. Beyond the homemade coneys and root beer, the Root Beer Stand was a popular cruising spot.

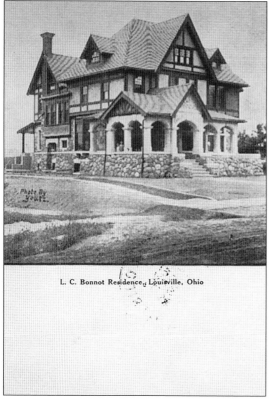

Photo By Youtz.

L. C. Bonnot Residence, Louisville, Ohio

The original Stier Funeral Home was in Paris, Ohio, on Lisbon Street, just east of the square. The Bonnot family erected the current funeral home building in 1900 as a private residence. It took 40 loads of fill dirt to build up the site because a waterway had run through this lot previously. Stier Funeral Home was moved from Paris to Louisville by Howard Stier in 1951; most Paris residents gave it business even after it moved. In 1968, the business was sold to Don Israel. Donald Israel III took over his father's business in 1990 and has continued his work in the old Bonnot home.

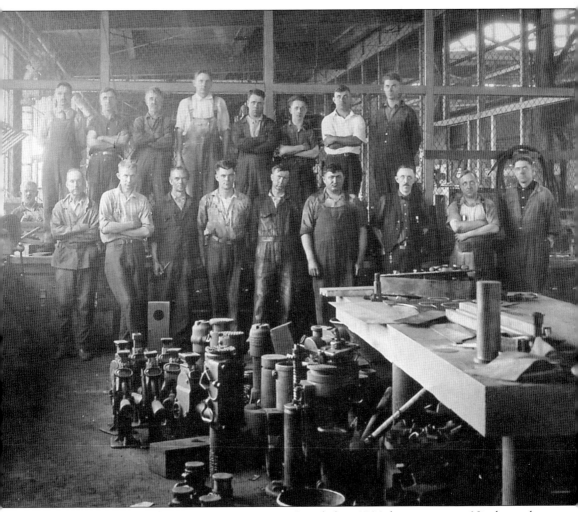

The Buckeye Jack Manufacturing Company was founded in 1904, but its owners, Nicolas and Casper Falla, tried to get the company off the ground as early as 1902. The company produced some of the early jacks for cars, railroads, and industry. In 1905, Buckeye Jack shipped its wares to Shanghai, showing the popularity of Buckeye Jack's product and how a local business could become known globally. This picture of the staff at Buckeye Jack is undated, and the men are unidentified.

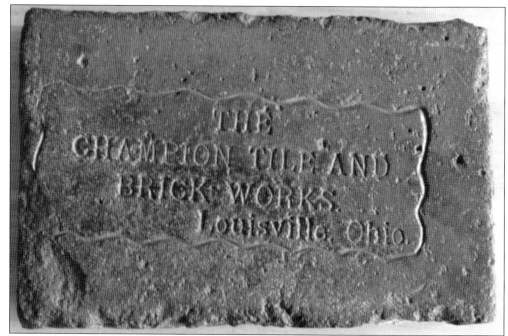

This tile might have been an advertising piece that the company gave to buyers, or a salesman might have presented it as a sample during a sales call. It could have been installed on a building somewhere. As stated on the piece, it was manufactured by the Louisville Tile and Brick Company. This relic is a physical reminder of one of the most prosperous industries in Louisville's history.

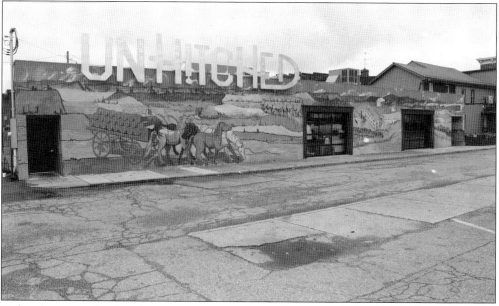

Today, there are only a few places to tie one on in Louisville. UnHitched Brewing Company opened its doors in Louisville in 2021 when the bowling alley was repurposed. The tables in the dining area are made of old flooring from the bowling lanes. The painting on the exterior is a copy of part of the Ferdinand Brader drawing of the Dilger Brewery that once existed in Louisville. (Photograph by Justus Grimminger.)

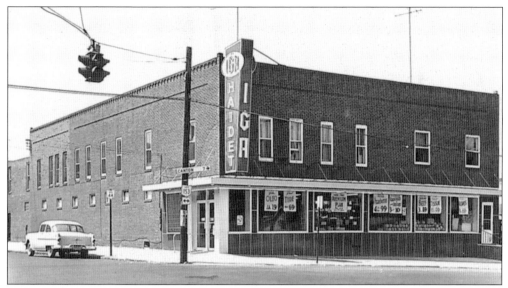

The Haidet IGA and the Fenton IGA (Fairhope) stores finished remodeling and opened in August 1926. This was the same year that the Independent Grocers Alliance (IGA) was formed to bring family-owned grocery stores together under one brand. In September 1973, there was a grand opening of Haidet's new building. Joe Mastroianni would eventually open Buckeye Village on this property, and it would become a privately owned Giant Eagle.

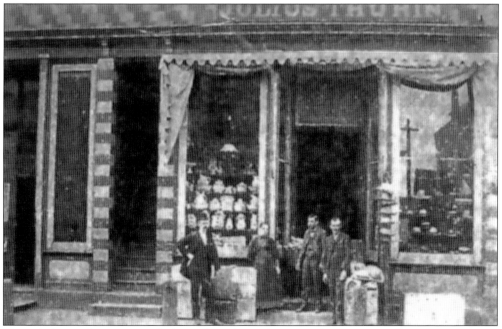

Thurin's dry goods store started when Julius Thurin (1838–1913), an emigrant from Saint Germain, France, along with R.H. Davis, bought out Morris Gantz's store. Davis and Thurin were in operation until 1880, when Davis retired. The firm became Julius Thurin and Sons. In this picture are, from left to right, an unnamed salesman, Amelia Thurin, Julius Thurin, and George First (store clerk).

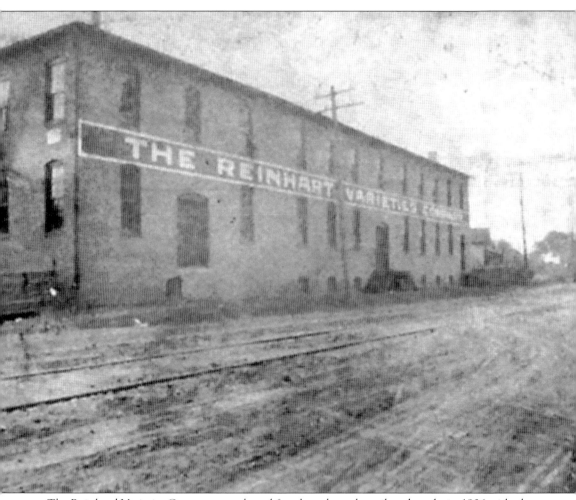

The Reinhard Varieties Company purchased four lots along the railroad tracks in 1906 with plans to construct a $20,000 complex consisting of a 3,584-square-foot main building and a 1,792-square-foot wing add-on. In late 1906, the construction of the new factory began, and in early 1907, the construction was complete. The company employed 29 people, and the primary stockholders were Isaac Harter, Louis Bonnot, F.E. Koehler, E. Rienhard, and J.S. Myers. Late 1907 saw the company add an east wing to employ its 58 workers, who labored 13 hours a day, mainly making drills and handles for tools. In 1950, half of the building was torn down and the other half became the Louisville Brass Foundry. The empty lot was used for Hudson and Essex automobiles, and later, Russel Yoder purchased it for his automobile repair shop.

Almanacs were very popular in the 1800s and early 1900s because of their use by farmers who received guidance on planting and weather. This 1909 *Town and Country Almanac and Handbook of Information* was published by the Slusser Pharmacy for use by its customers. Its pictorial cover would have invited people to use it and at the same time put in a plug for the business printed on the front.

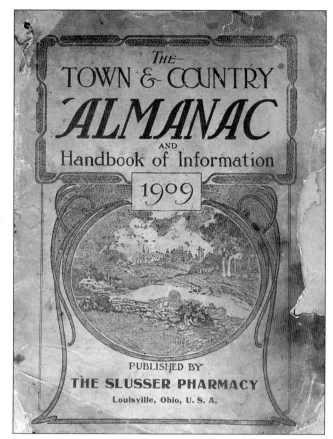

In 1928, Ohio Bell purchased this property at the corner of Main and Mill Streets from the Prenot family. This new building that the Ohio Bell company erected in 1932 would serve its purpose well, replacing the obsolete building that stood in that place since the latter part of 1859.

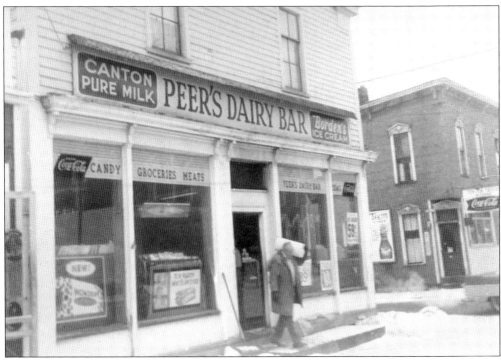

The Nimishillen Township countryside was heavily populated with dairy farms as was most of the county. Businesses like Peer's Dairy Bar at the corner of Main and Mill Streets in Louisville specialized in dairy products. Other businesses like the Louisville Sanitary Milk Company (established in 1919) sold milk from local cows. The township also attracted Swiss-born cheese maker and dealer John Martig (1877–1948). Carl Jussi's cheese house at 706 West Main Street came later.

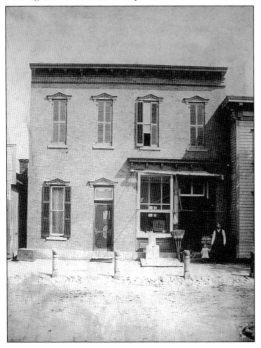

The inscription on the back of this cabinet photograph states, "JOURNOUX wholesale/CHERDRON." While Mark Brunner's reference work does not list any business with the name Journoux, he includes information on George Cherdron (1885–1955), who owned a grocery store in Louisville. Cherdron was born in Germany and lived in Cleveland before listing his Broad Street home address in the census. In 1926, Cherdron's bakery caught fire, but that is all that is known.

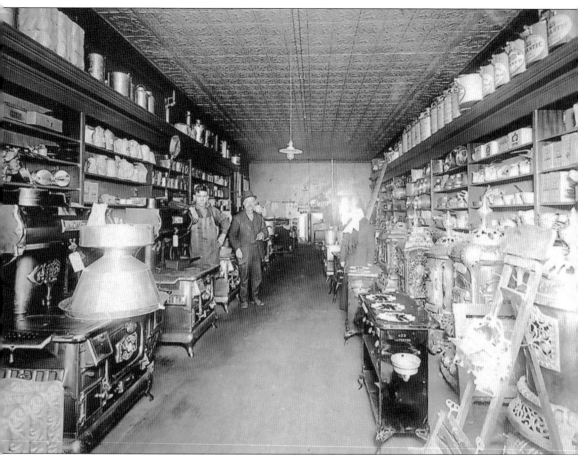

G.F. Bauman Store sold stoves and tinware on East Main Street downtown in the same building as Gantz Dry Goods and Pierson and Merley Hardware (on what was known as the Bauman and Merley Block). This storeroom shot offers a glimpse of the latest kitchen stoves that were fashionable at the time. From left to right are A.E. Schwab, G.F. Bauman, and Lydia Yoder.

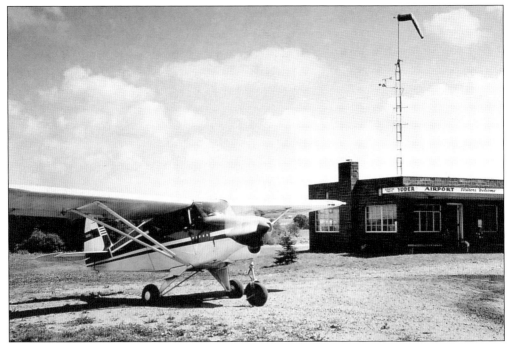

Louisville native Forest Yoder (1930–2015) was the manager of the Yoder Airport on Airpark Drive. A private pilot since 1947, Yoder built his own plane later in life. After serving in the Korean War, he and his family were self-supporting missionaries to Zambia, and then he served as the founding pastor of the Community Bible Church in Louisville. Yoder also worked for a time in his father's Oldsmobile dealership in Louisville. At the airport, locals could take flying lessons from instructor Tony Krall (pictured here) "for business or pleasure." The airport closed in 2010. It is no surprise that Forest's son Tim Yoder has had a successful career working for commercial airlines.

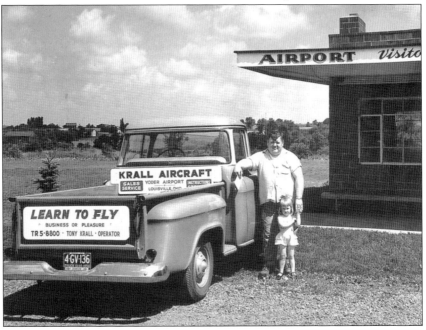

Louisville Milling and Elevator Company built a new barn and warehouse adjoining Star Mills in 1904. Levi Lautzenheiser, a descendant of one of the founders of Louisville, purchased a share in the company and, in the spring of 1906, completely owned the company. Unfortunately, it burned to the ground. The company would rebuild and would come into the hands of J.H. Miller & Sons (1912), Thomas Weir and Son of Altoona, Pennsylvania (1914), and W.G. Coates of Washington, DC (1916). Shown here are a cookbook and a knife that advertise this company.

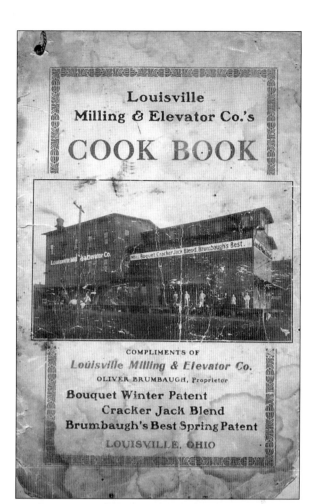

Louisville
Milling & Elevator Co.'s
COOK BOOK

COMPLIMENTS OF
Louisville Milling & Elevator Co.
OLIVER BRUMBAUGH, Proprietor
Bouquet Winter Patent
Cracker Jack Blend
Brumbaugh's Best Spring Patent
LOUISVILLE, OHIO

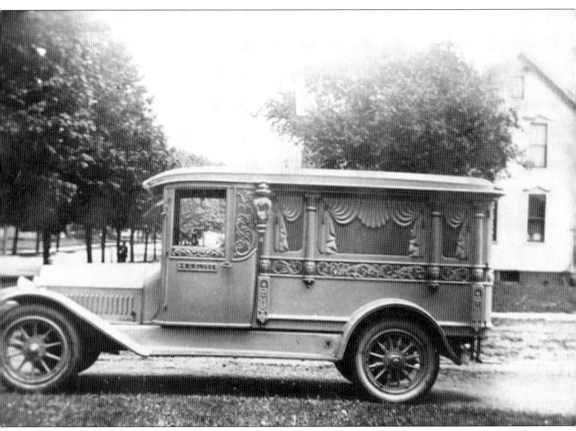

The funeral business has always been good in Louisville, and funeral directors here have long displayed the tools of their trade. The *Ohio Repository*'s May 20, 1869, issue announced, "Louisville now possesses two hearses to carry the dead. . . . One is owned by Peter Miller, and the other by Monsieur Paquelet. Both of the above-named parties make coffins to order." Slusser Funeral Home owned the hearse in this photograph.

In 1931, George D. Harter Bank bought the Louisville Bank at the corner of Main and Chapel Streets. Just two years later, bank robbers robbed the bank, taking $11,000. The bank would eventually move behind its original location into a new building. The Harter family notoriously reestablished banking in Canton in 1866 after a 10-year absence of banking that followed the closing of Farmers Bank.

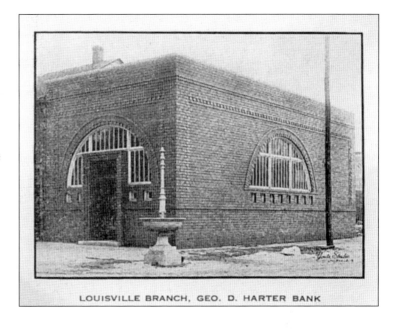

LOUISVILLE BRANCH, GEO. D. HARTER BANK

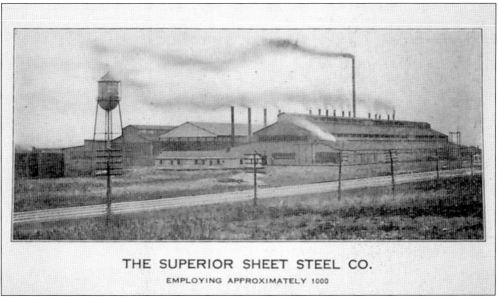

THE SUPERIOR SHEET STEEL CO.

EMPLOYING APPROXIMATELY 1000

The Superior Sheet Steel Company built a new factory west of town, along the Pennsylvania Railroad, in 1919. According to the November 27, 1919, *Louisville Herald*, the buildings measured 147 feet by 580 feet and 75 feet by 580 feet, helping the company to the point that its capital stock increased from $2 million to $4 million. The company soon reported having 800 employees.

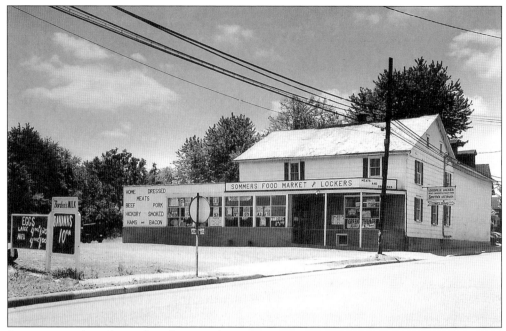

Sommers Food Market and Lockers was located at 100 West Main Street. Customers could buy groceries and meats at Sommers as well as rent meat lockers. This photograph from 1940 to 1950 was taken during a time before residents owned chest freezers. Renting a meat locker was one way that residents could preserve and store meat for future use.

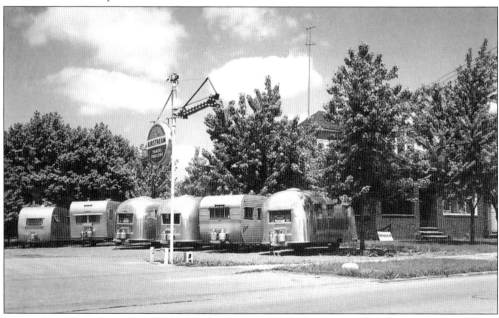

Louisville had an Airstream Travel Trailers dealer. Wally Byam started the company in the late 1920s, originally building trailers from Masonite. In 1936, the first aluminum Airstreams rolled off of the assembly line at a cost of $1,200 each. Out of hundreds of trailer companies in the 1930s, Airstream was the only one to survive the Depression. After World War II, the company built a plant in Jackson Center, Ohio.

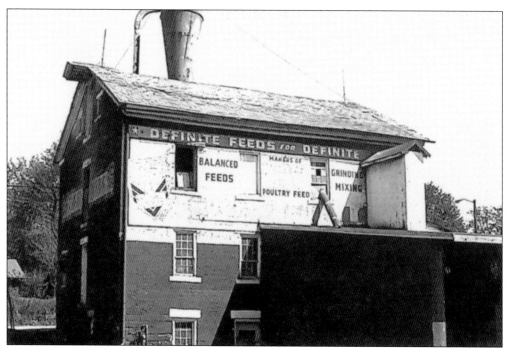

The Star Mill has changed hands many times throughout the last 175 years. Virgil Malmsberry bought this historic property in 1930 from Don Lathamer and sold it to Dale Buttermore in 1980. Interestingly, the Louisville Milling and Elevator Company used the previous mill building on this lot for storage after the owner at the time dismantled it.

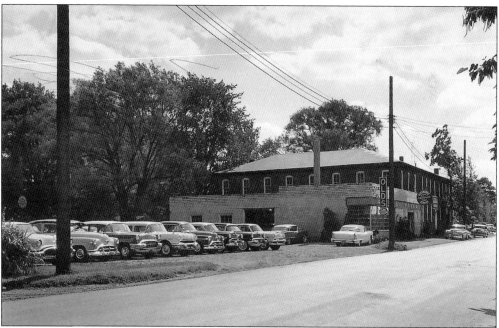

Russell Yoder opened his auto body repair and painting shop in 1930 at 112 North Mill Street. He later moved the business to West Main Street and then moved again to Depot Street. In 1940, Yoder became an Oldsmobile dealer and opened a new showroom in the 300 block of Depot Street.

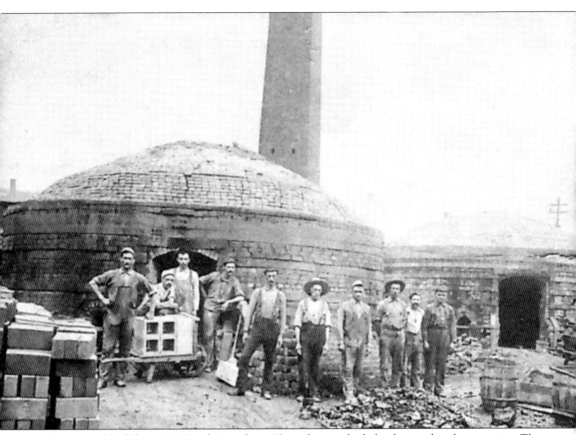

This view of the kilns at McGinty's introduces 10 employees who helped to tend to the operation. The *Herald* states on October 28, 1892, that "the new clay works east of town are being completed as fast as possible, a monster 100 horse boiler was taken out yesterday." Other Louisville brick manufacturers like A. Cheveraux and Company and Champion Tile Works were all doing good business.

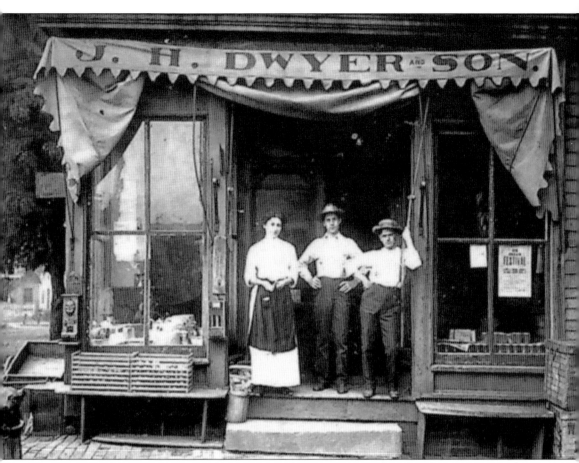

J.H. Dwyer and Son was a grocery store at the southwest corner of Chapel and Main Streets. John Henry Dwyer (1842–1910) was born in Dexter, Michigan, and married Catharine Maudru (1845–1953), a Roman Catholic from Maximo, Ohio. Their children Joseph (1876–1957) and Louis (1888–1958) were active in the family business. After John died, the *Herald* announced on February 10, 1910, that the business would be "continued under the name of Catherine Dwyer and Son, under the management of Louis Dwyer." Two years later, on March 28, 1912, the newspaper stated that "Frank Lyons . . . will be the new owner of Dwyer's grocery store." By 1914, the business must have been in the hands of Louis Dwyer, because it was made public that "Louis Dwyer will move his grocery store to the Freedy room on the corner of Main and Chapel Streets. The Lisch and Tournoux meat market was moved to the same location," as reported by the *Herald* on May 21, 1914. Louis sold half of the business to his brother Charles, and they renamed the business Dwyer Brothers.

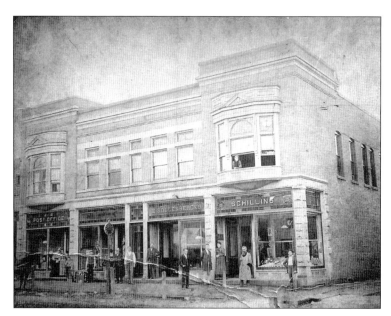

The Schilling Building (constructed in 1889) was home to a number of businesses over the years. At the time of this photograph, it housed four different businesses, including the US Post Office and H.L. Shirk (shoes and boots). Dr. John Schilling opened the first drugstore in Louisville in 1853.

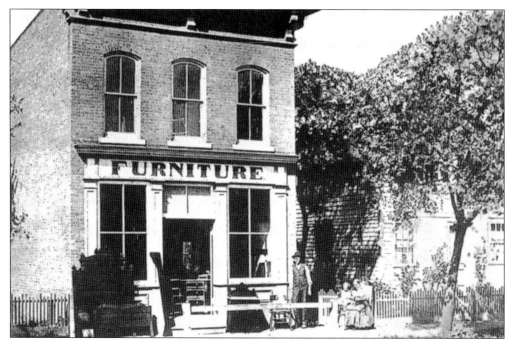

Stephen Paquelet (1837–1918) was a French-born furniture maker and dealer as well as an undertaker. He came to America in 1856 and Louisville in 1867. His first shop housed Phelix Doucat's wagon shop. Then, in 1887, he built the 20-by-40-foot building in this picture.

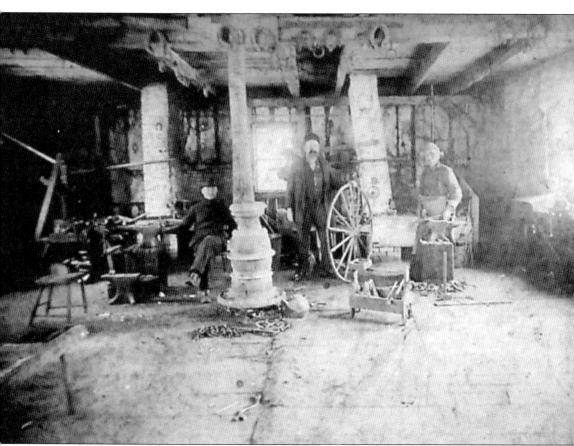

There is a long and somewhat documented history of blacksmiths in Louisville. This early picture of the blacksmith shop on the northeast corner of North Mill Street and Saint Louis Court shows the interior of an early Louisville workspace. The men in the picture are, from left to right, Henry Allison, John Myers, and Jacob Geis. (For more blacksmith names, see *Early Business in Nimishillen Township, Stark County, Ohio*, by Mark Brunner.)

William and John Kagey bought Lesh Grocery in Louisville in 1893, and William moved from South Bend, Indiana, to operate the store. In 1899, they were advertising that they were manufacturing their own candy. The downtown building that Kagey Brothers occupied was razed and a new building was erected in 1902. The store sold its own baked goods in addition to a general line of groceries. Other businesses bore the Kagey name: Kagey and First (clothier), Kagey and Gilbert (meat market), Ira Kagey (sawmill), and I.E. Kagey (filling station). These images offer a glimpse of what the Kagey store window looked like and how the store was organized.

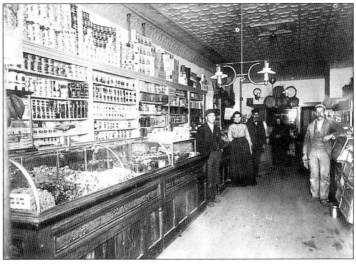

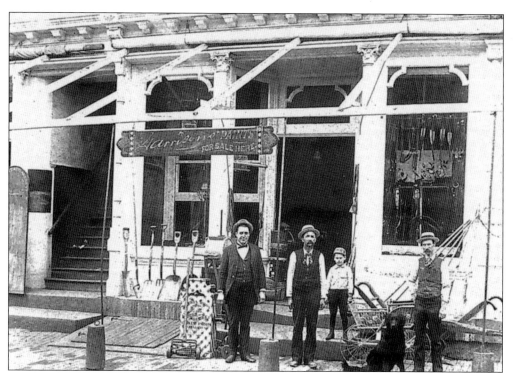

These two images are of the Keim Building at the corner of Mill and Main Streets. John Keim (1851–1909), who is pictured with two other men and a boy, took his business training in Pittsburgh, Pennsylvania, and then went into business with his father in the firm of Keim and Sons. He organized the Louisville Deposit Bank in 1881 and became the sole owner of the banking and hardware companies, located in this building, in 1893. He was also instrumental in starting the Louisville Brick and Tile Company and the Keim Brick and Tile Company (established in 1904). He served as the president of Empire Clay Company in Louisville as well.

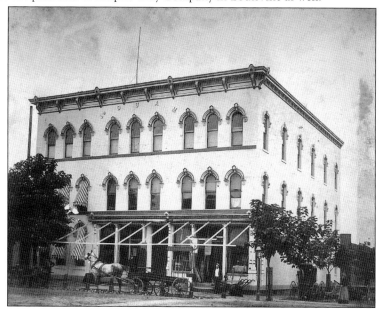

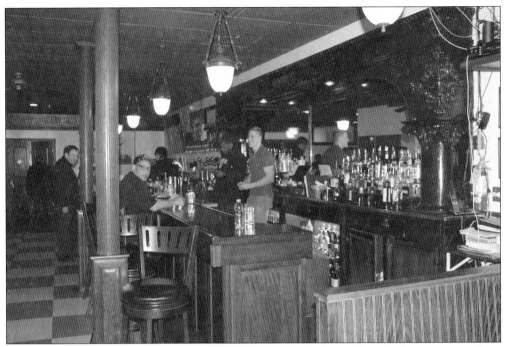

Scratch Steakhouse and Lounge has gained a reputation for its dry-aged steaks, bringing something entirely new to Louisville. A graduate of the Pennsylvania Institute of Culinary Arts, Demond Germany owns and operates this establishment, contributing to the success of downtown by attracting people from all around the state. The bar counter once stretched from the entrance back to the kitchen, and legendary athlete Jim Thorpe signed a contract in the basement. (Photograph by Justus Grimminger.)

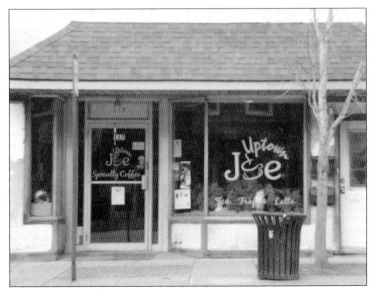

Uptown Joe opened in 2014 in the old Isaly's store in downtown Louisville. Owners Kenny Clark and Diane Clark (1956–2021) created a meeting place for people to gather and enjoy everything from coffee and espresso drinks to sandwiches and pastries. In late 2022, a second location started in the Alliance Community Hospital. Uptown Joe is part of the revitalization of downtown Louisville.

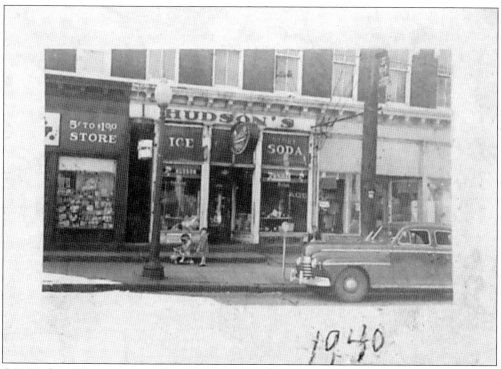

C.E. Hudson Pharmacy was a Rexall store, originally a partnership between C.E. Hudson and Charles Slusser. In 1919, Hudson bought out Slusser's share of the business entirely. The *Louisville Herald* detailed drugstore changes and staffing throughout the years. One can imagine how exciting it was for locals to read that Hudson installed a new iceless soda fountain in 1920.

Paul Rebillot and Sons is one of the few businesses in Louisville owned and operated by the same family for almost 100 years. According to census records, the Rebillots were farmers in Nimishillen Township as far back as 1860 and butchers for almost as long. Their butcher shop operated between 1876 and 1962. They gave out these beautifully illustrated calendars to their customers annually.

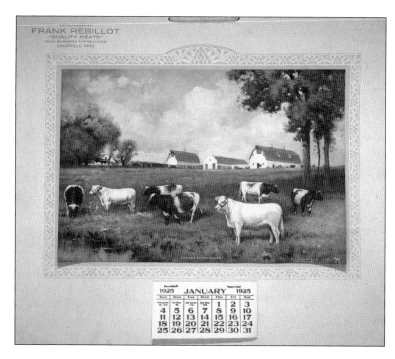

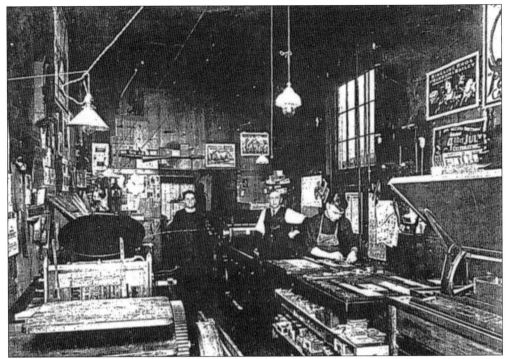

L.P. Bissel came from Medina, Ohio, to start the *Louisville Herald* in 1887. By 1890, the *Herald* occupied the whole east room of the Thurin Building, a space it had shared with the post office. Augustus F. Juilliard became the new editor in 1893, followed by John C. Prenot in 1897. Louis Clapper (pictured here) was the next editor and owner.

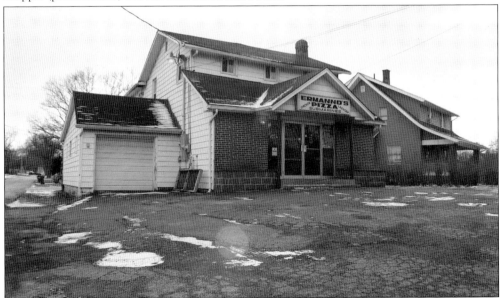

Ermanno's Pizza Shop started in 1968 and was located on West Main Street. Up until 2019, Michael Lynch, whom customers called "Crazy Mike," was always in the shop on Friday nights, making pizzas for customers. Even though there was a dispute after Lynch's death over ownership, the pizza shop continues to make pizzas, wings, subs, chicken, salads, and more.

Six

MUSIC AND THE ARTS

Nineteenth-century Americans were immersed in music. Sacred music and singing were particularly prominent in their lives. Catholics heard the ancient Gregorian melodies of the Mass, and German Protestants sang their chorales (hymns) that had their foundation in the 16th century. To educate the public, and to learn sacred repertory, singing schoolmasters would travel the country, holding singing schools in churches and other designated places. One such teacher, William Lowery, held singing school in the Lutz School east of town. Some area churches, like Beech Mennonite, held singing schools. One lifelong member at Beech said that these happened even into the 20th century, because he would attend to meet young ladies. The Pennsylvania Dutch especially liked to hold singing schools, and this may be why they knew their chorales from such an early age.

As churches became more established, most of them obtained either a pipe organ or reed organ. The immigrants in Louisville would have remembered the great organs and organ music in their European home countries. Pennsylvania Dutch people would have remembered or heard stories of the great organs in Pennsylvania churches built by Klemm, Tannenberg, Krauss, and others. A number of pipe organ companies sprang up in Ohio. As ladies in Louisville embraced the ideals of the Victorian era, they sought reed organs and pianos for the parlor room of their homes. There were at least 247 manufacturers of reed organs in America and even more piano makers. This encouraged singing in the home and the purchase of sheet music, an essential element of every Victorian home.

Bands sprang up in every American town in the 1800s, and Louisville was no exception. According to author Robert M. Hazen in *The Music Men: An Illustrated History of Brass Bands in America, 1800–1920*, they "performed virtually everywhere—at picnics and parties, dances and rallies, weddings and funerals. . . . By the end of the nineteenth century, open-air concerts in the community bandstand had become so integrated into American life that people often arranged their weekly routines around performances." Louisville also produced world-renowned singers, actors, artists, and patrons of the arts.

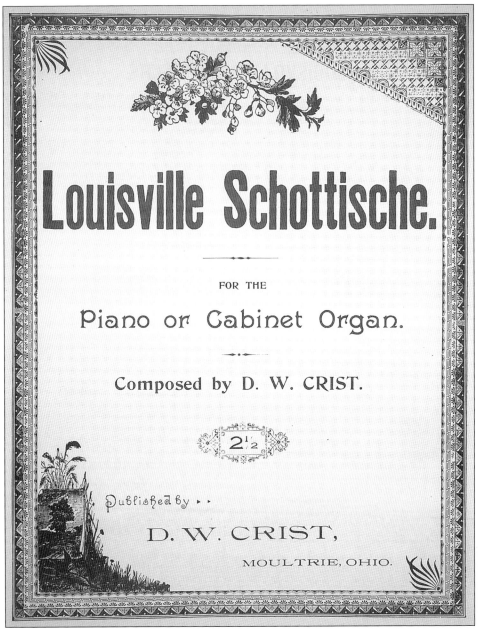

Sheet music was prevalent in every Victorian home at the end of the 19th century. As something the pianist would play in the formal parlor room, it was a way that families and guests could enjoy time together and explore far-away places without leaving their houses. Oftentimes, the music would be in a dance form, like the music pictured here. D.W. Crist, a local composer, editor, and publisher of music in Moultrie, Ohio, printed "The Louisville Schottische" in 1886. Crist dedicated it to Louisville resident "Miss Jennie Ream." A Schottische is a European folk dance originating in Bohemia. If the pianist was playing for dancers on the parlor-room floor, the dancers would have two sidesteps to the left and right, which would be followed by a turn in four steps. Sheet music like this was a very lucrative business, which is why pieces like this were named and dedicated in such a specific way, boosting sales to local people.

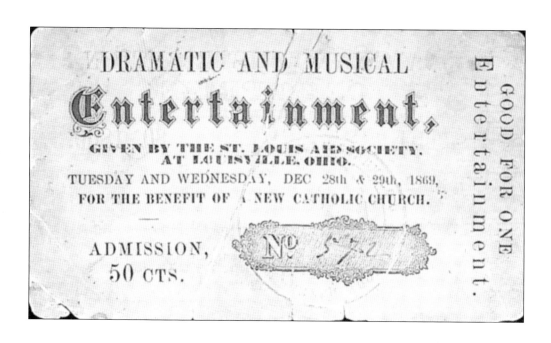

In 1869, the Saint Louis Aid Society held a grand event on December 8 and 29 to raise money for the construction of a new church building. Among the prizes was "a good horse, worth about $100." The ticket states specifically that there would be dramatic and musical entertainment in addition to the raffle giving every ticket holder the chance to win 50 different prizes. This event took place the same year that the original brick Saint Louis church building was taken down and work on the current church building began. The 50¢ cost of admission would have been expensive, yet the chance to win such grand prizes would have made it worthwhile in the minds of the attendees.

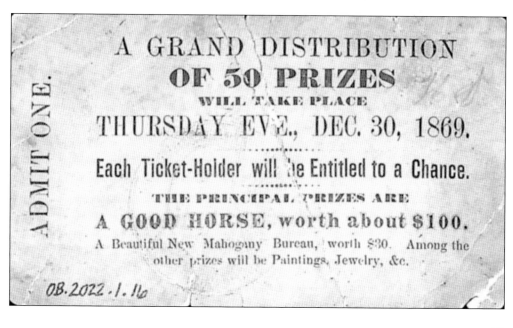

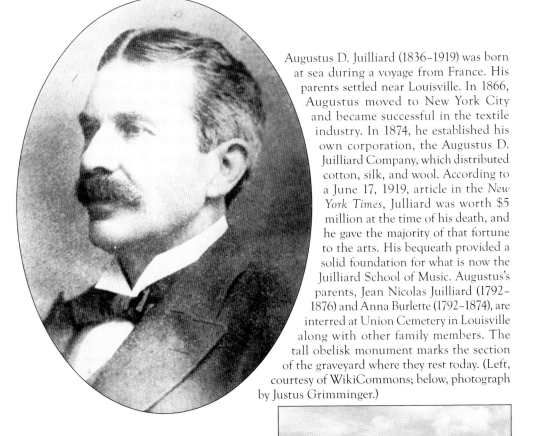

Augustus D. Juilliard (1836–1919) was born at sea during a voyage from France. His parents settled near Louisville. In 1866, Augustus moved to New York City and became successful in the textile industry. In 1874, he established his own corporation, the Augustus D. Juilliard Company, which distributed cotton, silk, and wool. According to a June 17, 1919, article in the *New York Times*, Julliard was worth $5 million at the time of his death, and he gave the majority of that fortune to the arts. His bequeath provided a solid foundation for what is now the Juilliard School of Music. Augustus's parents, Jean Nicolas Juilliard (1792–1876) and Anna Burlette (1792–1874), are interred at Union Cemetery in Louisville along with other family members. The tall obelisk monument marks the section of the graveyard where they rest today. (Left, courtesy of WikiCommons; below, photograph by Justus Grimminger.)

The Louisville High School marching band used these uniforms from the 1940s until recently. Band uniforms like these have their roots in the Middle Ages and show military influence in their ornamental trim and decoration as well as their use of wool cloth. The white straps that cross at the chest have a particular military look about them.

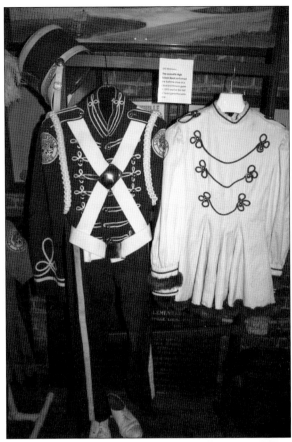

This blurry 1949 photograph shows the Louisville High School marching band marching through the intersection at Main and Chapel Streets. It offers a glimpse of what that intersection looked like before the historic buildings at that intersection came down for the businesses that occupy that land today. The traditional look of the band and majorette uniforms is apparent when compared with the style today.

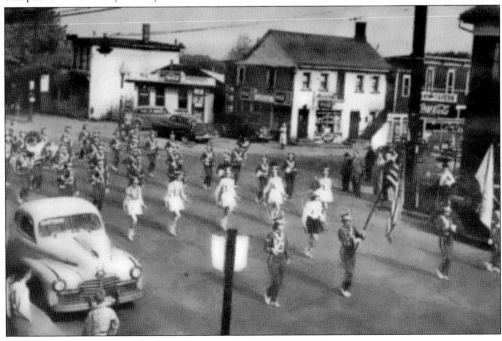

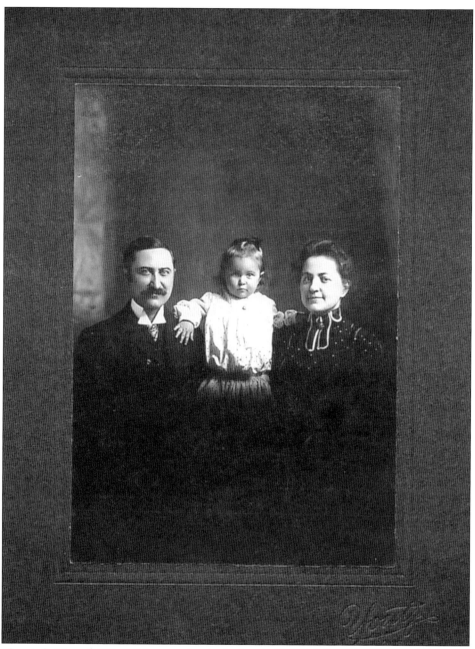

Dr. Louis S. Vinez (1867–1945) was a dentist in Louisville's Schilling Building and then in the Bauman Block. He used the latest equipment in his practice and served in various key offices in the Ohio Dental Association and the Stark County Dental Association. Interestingly, he was a trained musician and music teacher who advertised his piano and organ studio in the March 4, 1887, issue of the *Louisville Herald*. It was announced in the May 26, 1910, issue of the *Herald* that Vinez was retiring from being the organist at Saint Louis Catholic Church after 20 years of service to the church in that position. He was also mayor of Louisville from 1900 to 1906. This is a Vinez family portrait showing Louis with his wife, Regina, and baby Mary (later Mary Bauman). Louis is buried in the Saint Louis Cemetery.

ENTERTAINMENT

Saturday Evening, June 15th, 1889,

AT KEIM'S HALL,

FOR THE JOHNSTOWN RELIEF FUND.

PROGRAM.

CHORUS—Gathered Once More................................*McGranahan*

RECITATION—The Convict's Christmas Eve...............
Lillie Keim.

INSTRUMENTAL DUET—I kissed you in a dream..............*Sousa*
Florence and Frank Chappius

DOUBLE QUARTET—Come Where the Lillies Bloom.........*Thompson*

VOCAL SOLO—Ave Maria.....................................*Cherubini*
Mrs. Emma Wertz.

RECITATION—Gone with a Handsomer Man..................
Corinna Thurin.

PIANO SOLO—Last Hope....................................*Gottschalk*
Louis Vinez.

VOCAL DUET—Oh, Happy Swallow............................*Kucken*
Anna and Mary Bauman.

RECITATION—The Legend of the Organ Builder
Anna Powell.

VOCAL SOLO—Selected.....................................
Ada Slusser.

INSTRUMENTAL DUET—Fantasie.......................*Theodore Hoch*
Messrs. Vinez and Sassaman.

RECITATION—Sister and I
Mary Baker.

QUARTET—The Fortune Teller..............................*Leslie*

PIANO DUET—Zeta Phi....................................*Kickok*
Mr. and Mrs. M. Coy.

RECITATION—The Skeptic's Daughter......................
Sevilla Geib.

VOCAL SOLO—When the Tide Comes In.....................*Millard*
Minnie Sauvageot.

CHORUS—Good Night

GENERAL ADMISSION, 25 CENTS.

When locals heard about the Johnstown flood (May 31, 1889), they organized a concert to help the victims of the disaster. This program details the concert on June 15, 1889, that took place in Keim's Hall (likely where the Masonic hall was dedicated in March 1920), on the northwest corner of Main and North Mill Streets, on June 15, 1889. The performers are familiar Louisville names, and the music they performed was typical of Romantic American programs. Notice how the titles of the selections tap into the Romantic imagination and the 19th-century preoccupations with nature, religious piety, Greek antiquity, and love. The pastiche of different instrumental, vocal, and piano music in combination with the reading of texts created a patchwork that would have held the attention of everyone who attended the event.

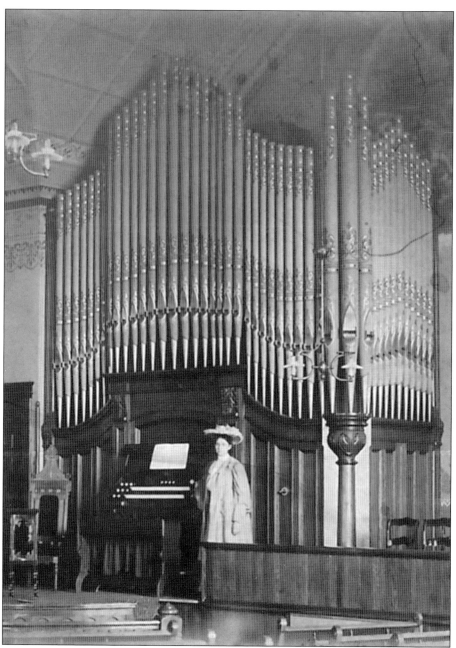

The woman in this photograph is likely Regina Vinez, wife of Saint Louis organist Louis Vinez. The back of this cabinet photograph bears the pencil inscription "L.S. Vinez." The organ is typical of late-19th-century church pipe organs, especially in its painted facade pipes, which would have combined colors and patterns that mirrored the exterior of Victorian houses. Unlike many of the pipe organs built later in time, this is a tracker action organ that used long strings ("trackers") to mechanically let air from the windchest up through the pipes. As a result of the direct connection the organist had with the pipes, how the musician attacked the keys was evident in the way the music sounded. It is not clear where this organ was located, but it is clear that it was in a church, as a Victorian altar chair and pews are visible in the photograph.

Ruth LaVonne Clapper (1918–1999) was the daughter of Louis Clapper, the owner of the *Louisville Herald*. In 1949, she married Arthur Lindstrom (1918-1980), who was a native of Fairfax, Missouri. Ruth was a professional singer (soprano) who made a singing career in her early years in New York City. Arthur studied at the prestigious Juilliard School of Music and Columbia University. When they came back to Ohio to live, Arthur became a professor of music theory, piano, and organ at Mount Union College, and Ruth would often teach some of the classes for Arthur, who was the professor of record. She maintained a private voice studio in their home on Main Street. Arthur was the director of music at Saint Paul Lutheran Church in Alliance.

Pat Rebillot was born in Louisville in 1935. After studying at Mount Union College and the Cincinnati Conservatory of Music, he made it big in jazz, playing with famous artists as a pianist and organist. He is likely the most famous musician to come from Louisville. In an interview on the *Jake Feinberg Show*, Rebillot credited his early years as an organist at Saint Louis Church with his later success.

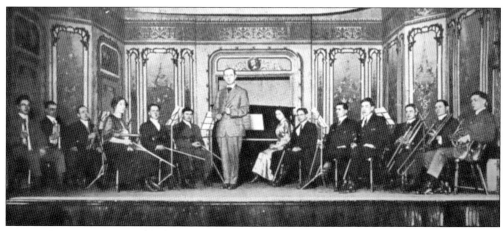

Frank Clapper directed the Verdi Orchestra, and Nora Clapper was the pianist for the ensemble. The ensemble likely performed art music from the 19th century, the time in which Giuseppe Verdi (1813–1901) lived. It is also possible that they accompanied singers who sang operatic works by Verdi and others. This would have been highly desirable in a place like Louisville at the turn of the 20th century.

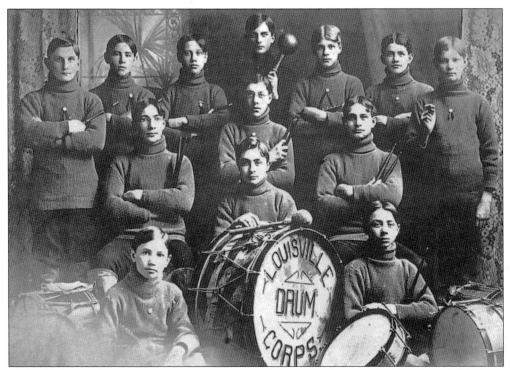

Louisville has been home to many bands: a drum corps in 1861, the Louisville Brass Band in 1875, and the Louisville Excelsior Band in 1877, among others. This is likely the independent drum corps established in 1888. Members have been identified in the Thurin family record as, from left to right, (first row) Edward Clapper, Harry Bailet, and unidentified; (second row) Marion Thurin, Lloyd DeVaux, and unidentified; (third row) N.N. Schloneger, Louis Clapper, Frank Clapper, and three unidentified persons.

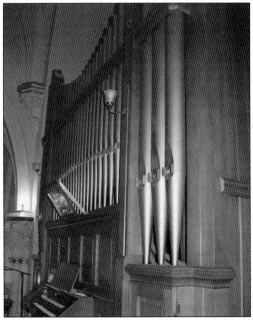

Saint Louis Church follows the Christian tradition of balcony organs. While the congregation would not have sung much during Mass until the Second Vatican Council (1962–1965), which called for more congregational participation, this organ would have played more special music in the liturgy than hymn accompaniment. This is the side view of the organ case with its gold facade pipes. Henry Pilcher's Sons (of Louisville, Kentucky) built it in 1898. (Photograph by Justus Grimminger.)

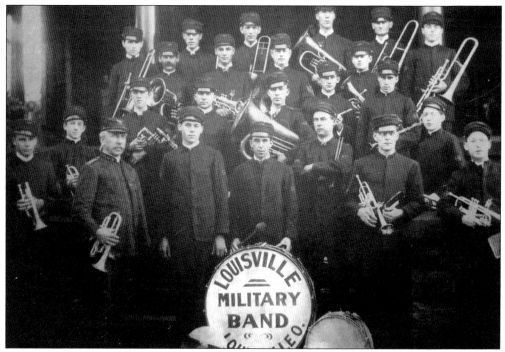

The tradition of using bands in war to influence and direct troops and to entertain military personnel goes back to at least the 13th century. Many towns throughout Ohio and Pennsylvania had "military bands" at the end of the 19th and the beginning of the 20th centuries. But the name is misleading, because these civilian bands were not associated with the military. Instead, they received their name because the music they played was arranged for the same instruments that true military bands had in them. Bugles (or sometimes natural trumpets and horns), bagpipes at times, woodwinds (like fifes), and drums were the standard instruments in these ensembles. The Louisville Military Band would have played at rallies, picnics, and parades in and around Louisville at the least. They likely traveled to other towns for similar events as well.

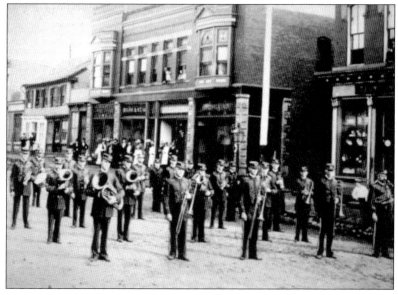

Pat Ickes (1948–2001) was a very talented organist, pianist, accompanist, and improviser. While he was not from Louisville, his father graduated from Louisville High School. Pat's death was untimely. His tombstone in Union Cemetery shows Pat at the piano on the front, and the top of the stone is decked out with several octaves of piano keys. The text on the stone, "My life flows on in endless song," comes from Robert Lowry's hymn "How Can I Keep From Singing?"

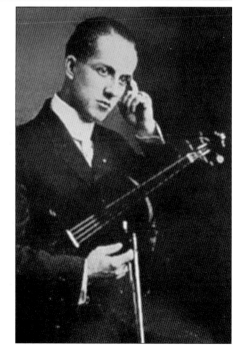

Ira F. Bratten was one of at least six violin teachers who taught in the city of Louisville from 1910 to about 1935. His advertisement appeared in the *Louisville Herald* starting in 1910. The Bratten Studio consisted of Ira and Blanch Bratten, who was a piano teacher. Their studio was at the corner of Mills and Gorgas Streets.

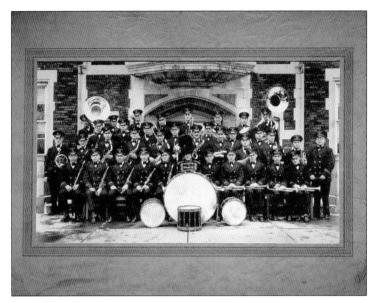

This unlabeled town band photograph shows musicians with "Louisville" spelled out above a lyre on each hat. A name on the back may tie it to Lee Warstler, who directed the Lee Warstler Orchestra, advertised in the *Louisville Herald* in 1936. Warstler's ensemble played on WHBC radio station on Sunday afternoons and performed live for audiences in the Knights of Columbus Hall on Saturday nights.

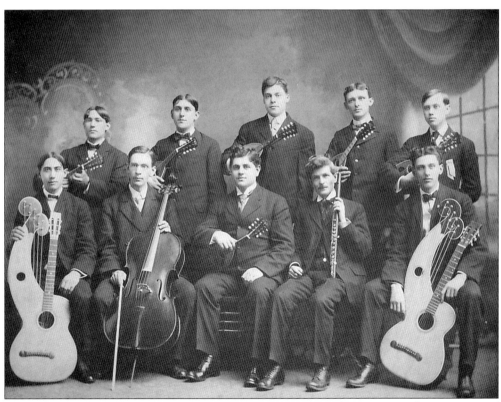

The Big Six Mandolin Club, which advertised as "A 'Gay Nineties' Organization," was comprised of an unusual combination: six mandolins, a cello, a wooden flute, and two unique guitars. Each guitar had six strings on the fretted neck of the instrument and ten strings that were unfretted. Band members included Arthur Rogers, John Lesh, William Bowen, Joseph Clapper, Edward Myers, and Perry Clapper.

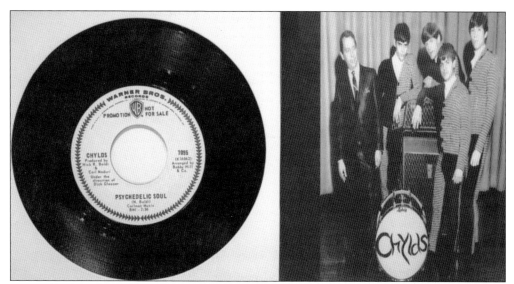

Originally the Echoes, this band changed its name to the Chylds when it recorded on the Warner Bros. label and the manager wanted the band to be the Wild Chylds. The members were John Berecek, Al Twiss, Tim Hogan, and Joe Vitale. They opened for the Beach Boys and Mitch Ryder. Vitale was the only one to make a career in music, later performing with the Eagles and Crosby, Stills & Nash.

Shirley Givens (1931–2018), "the Louisville Violinist," born in Louisville, beat over 26,000 other violinists in Pasadena, California, at the age of five. She attended the Juilliard School and played for television, including *The Ed Sullivan Show* and *The Arthur Godfrey Show*. Pres. Dwight "Ike" Eisenhower invited her to the White House to play. She married her Vienna-born Juilliard classmate Harry Wimmer, a cellist, and they both performed in the Radio City Music Hall Orchestra.

Chester Bratten (1897–1977) was commissioned to do the artwork for Wrigley Spearmint Gum as well as this very famous painting of US president Dwight "Ike" Eisenhower (below). Bratten also painted this portrait of himself (left) using watercolors in 1971. It was a gift to the Louisville-Nimishillen Historical Society, but it was not certain who was in the painting until a descendant of the artist confirmed the subject's identity. Another local installation of the artist's work is at the First Brethren Church (corner of Main and Nickel Plate Streets): *Jesus in Gethsemane* is a large-format painting. As was traditional in local Brethren churches, it used to hang in the chancel (above the altar) so that worshippers could see it during worship. Now it hangs in the nave, on the north wall of the worship space.

As part of downtown Louisville's revitalization, "Umbrella Alley" was installed as a permanent attraction that draws people from across the state and beyond. It features hanging umbrellas overhead in vibrant colors, flanked by brick walls that locals have painted. Louisville now hosts "Second Friday," when people come to town on the second Friday of the month to shop from street vendors and storefronts. Now, during good weather, one can see young and old alike visiting this installation and taking pictures.

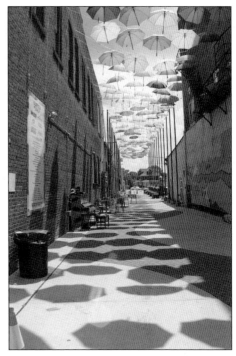

The German American Club (also known as the Arion Club) built its clubhouse in 1930 on Georgetown Road. It was here where the Arion Singing Society (Arion Gesangverein) sang. Established in 1894, the men in this choir met weekly to practice for their seasonal concerts. Events like the club's annual Traubenfest and annual Oktoberfest drew crowds for dancing, German food, and Polka music. The club sold the property in 2010 for $150,000. (Photograph by Justus Grimminger.)

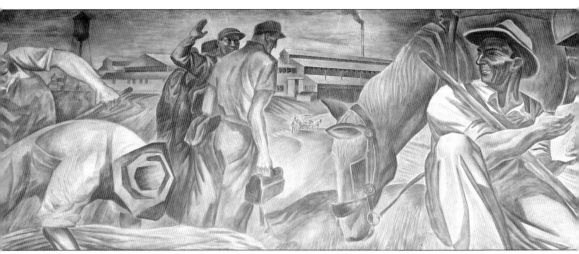

Farm and Mill used to hang in the old post office on Main Street until the postmaster relocated it to the new postal building on Chapel Street. It was painted by Herschel "Harry" Levit (1912–1986), born of a Russian immigrant father in Philadelphia. The work depicts two of the most important industries in the history of Louisville and Nimishillen Township. After graduating from the Pennsylvania Academy of Fine Arts, Levit worked in the media of painting, lithography, and photography. He taught at Pratt Institute (1947–1977) and Parson School of Design (1977–1986). He was part of the important team of artists who brought beauty into the lives of common Americans as part of the Federal Art Project, sponsored by Pres. Franklin Roosevelt's Works Progress Administration (WPA). Permission to use this image is courtesy of postmaster Jeffrey Wheeler. (Photograph by Justus Grimminger.)

The Louisville Art and History Gallery is operated by the Louisville-Nimishillen Historical Society. Since November 2014, local artists have exhibited their artwork in this gallery, and various art classes have been offered to the public. The historical society also makes use of this space for historical presentations. Art in a variety of media is available for purchase here.

Louisville High School students put on the operetta *H.M.S. Pinafore* by Gilbert and Sullivan in March 1949. The cast included Barbara Pasco, Dorothy Ulrich, Birdine Lotz, Joanne Dreschler, Ronnie Miller, Don Nupp, Don Williamson, Virgil Stan, Mike Thomas, Bill Fisher, and Tom Haren. *H.M.S. Pinafore* was first performed in London in 1878 and was the second longest-running musical theater production of that day. It was still popular in 1949.

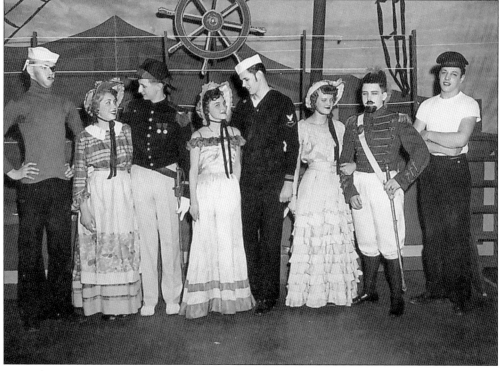

The Louisville Community Choir was organized in the 1980s and was directed originally by Dr. Paul McGahie, who was the music director at Christ United Methodist Church. McGahie holds degrees from Westminster Choir College, the University of Oklahoma, and the Cincinnati College–Conservatory of Music. The current mayor of Louisville, Patricia Fallot, serves as the current director. Pictured below are singers in the choir rehearsing in the fall of 1984, and at left is a portrait of McGahie from an article announcing the choir's 1984 concert. According to the *Louisville Herald* on February 20, 1930, another community choir existed 50 years before: "The community chorus will rehearse TO-NIGHT at the First Brethren Church between the hours of 7 and 8. Every member is urged to be on time, as another meeting is scheduled to follow the rehearsal." (Left, used with permission of the *Louisville Herald*.)

Seven

COMMUNITY, PLACES, AND PEOPLE

People, places, and events are tied together in history. Many things happen in a community that have key players and particular locations. In the case of Louisville, that is also true. Over the last 75 years, the communal memory in this town often goes back to the annual Constitution Day festivities, something that Olga Weber worked hard to establish. The crowning of a queen and her court is an annual tradition. There are also events that happen once like the welcoming home of troops from the Spanish-American War, depicted on the front cover of this book, or the homecoming of a soldier who has died in combat. These events and people brought the community together.

There are special places within the town that have also had an impact on the people and community of Louisville. One needs to look no further than the last day that the public was allowed to walk into the space at the old Louisville Middle School or the final goodbye at Pleasant Grove Elementary School to see how a particular place is dear to a community.

Key people have a special place in the building and nourishing of the community. This has been true of postmasters, from the first one, Sam Petree, to the current one, Jeffrey Wheeler. These leaders have contributed something special to the community through their service and interaction with the people they serve. Then there are those who have gone away and become famous or gained prominence in their professional work: they are instrumental in rekindling the community when they are encountered outside of the town or come back. These are people like Bob Gladieux, Alan Harold, and Paul Rebillot.

This chapter is a collage or pastiche of events, people, and places that remind one of the community latent in Louisville. Each image leads back to community in some way or another.

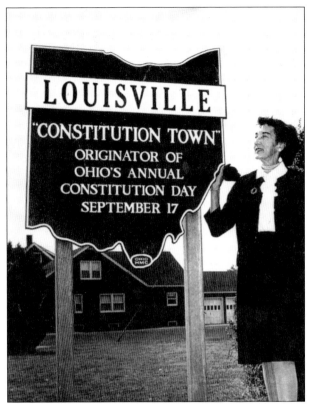

It is because of Olga Weber (1903–1978) that Louisville became the "Constitution Town," which the city council approved on April 15, 1953, after years of Weber's advocacy. September 17 became Constitution Day on the state level thanks to Weber, and Louisville eventually started its annual Constitution Day parade with other festivities. Here Weber poses with one of four historic markers given to Louisville by the Ohio State Archeological and Historical Society.

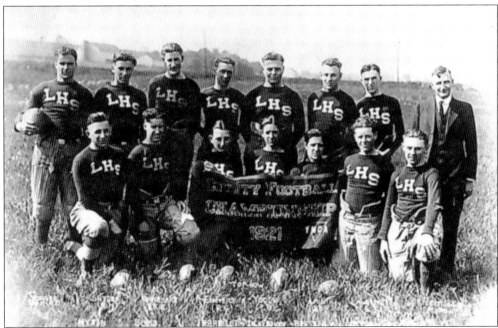

Football has been an important pastime in Louisville since the beginning of the sport. It is no secret that the game originated in Stark County, making Louisville boys early players of the game. In this photograph, the 1921 high school team celebrated their victory as the Stark County champions.

In 1959, Louisville celebrated 125 years of existence as a town in a "Centi-Silverama" celebration that lasted for a whole week. Many men grew mustaches and beards and received certificates that declared them "Brothers of the Brush." Similar hair-growing activities took place during nearby Paris's sesquicentennial festivities in 1964.

As a part of Louisville's Centi-Silverama festival, there were a number of badges that people in the town collected. Some were for the Brothers of the Brush, who grew beards and mustaches for the party. Others were for women, calling the wearers "silver belles." This collection of badges in the Louisville-Nimishillen Historical Society collection shows that people were proud of their city and enjoyed every minute of the celebration.

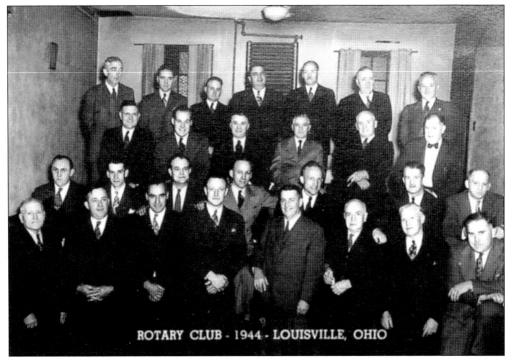

ROTARY CLUB - 1944 - LOUISVILLE, OHIO

Auxiliary organizations have been an important part of the town's past and present. Such organizations often have left their mark on buildings, as did the Masonic lodge and the Junior Order of United American Mechanics on the Keim Building. Two such organizations, still present today, are the Rotary Club and the Eastern Star. The 1961 Eastern Star picture provides a portrait of each member with the position that each held within the organization. The earlier 1944 Rotary Club photograph brings together the membership in one group picture.

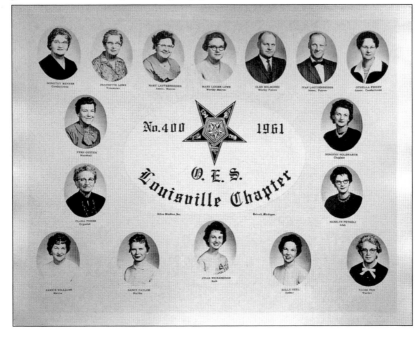

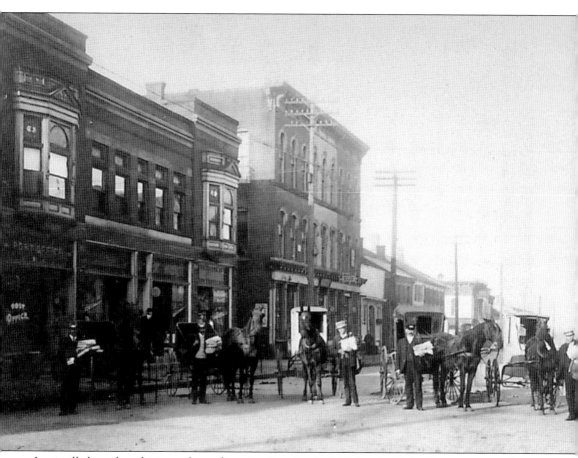

Louisville has a long history of postal service. Starting in 1837, Louisville had its own post office, and the postmaster became one of the most respected positions in the town. In this rare photograph, all of the Louisville mail carriers pose with their horses and carriages in front of the downtown post office in the 200 block of East Main Street. The men in the photograph are, from left to right, M.L. Justus, Harvey Criswell, Harry Warstler, Frank Sluss, and Harvey Royer. The post office space at that time was in the Schilling Building, where Metzger Hardware was in the latter half of the 20th century. The US Postal Service would erect a new building on East Main Street in the 1920s and an ultra-modern edifice on North Chapel Street in the 1980s. The architectural beauty of the post office, pictured here, has been lost in the current post office design.

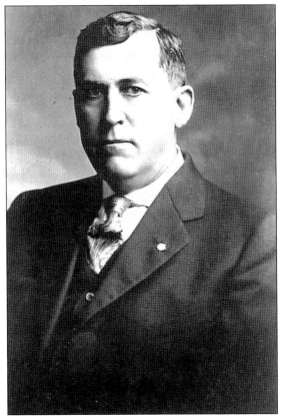

The John Keim House was built in 1905 at 418 East Main Street. It would later be owned by John Martig in 1924 and house the Louisville Public Library and, later, the superintendent's office for the public school. This was one of several grand houses that the Keim family owned as a result of John Keim's fleeting wealth.

Census records show that John Keim (1851–1909) lived with his parents in Osnaburg Township (in 1860) and then went from being a clerk (1870) to a hardware dealer (1880) to a banker and manufacturer (1900). As is often the case, Keim had an advantage because his father, Moses Keim, had the means to purchase William O. Myers's interest in Myers Brothers, which became the seed that grew into the Keim and Sons company.

The Louisville Public Library has contributed to the intellectual growth and pleasure of Louisville residents for many years. A new contemporary building provided for expansion compared to the limitations of the library's previous home in the Martig (Keim) House. This 1969 picture shows the building when it was freshly constructed.

Menegay's Swimclub was a very popular place with Louisville's youth. According to advertisements, Norbert Menegay (1889–1965) was a dealer of sand and gravel, but it was Richard Menegay and Raymond Dwyer who started Menegay's Swimclub, converting a gravel pit into a pool. According to an advertisement in the June 24, 2004, *Louisville Herald*, it became "one of the largest and finest cement pools in the state of Ohio." Richard also built the original Dairy Queen.

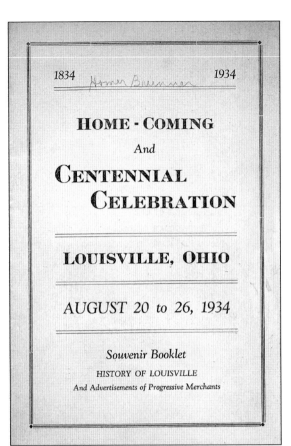

1834 *Homer Brunner* 1934

HOME - COMING

And

CENTENNIAL CELEBRATION

LOUISVILLE, OHIO

AUGUST 20 to 26, 1934

Souvenir Booklet

HISTORY OF LOUISVILLE

And Advertisements of Progressive Merchants

Louisville celebrated its 100th year with a homecoming. Family and friends came back to Louisville from all around for this celebration. This is the cover of the booklet that was distributed at the event. The booklet is one of the first comprehensive histories of Louisville in the hands of the public.

The 1984 Louisville Fire Station No. 2 personnel pose for this picture beside one of the fire trucks. The names of the staff are, from left to right, Rick Babcock, Bob Shannon, Dave Williamson, Ruth Argenio, Kay Tesch, Dave Daugherty, Tom Ruskin, and Capt. Ronald Bordner.

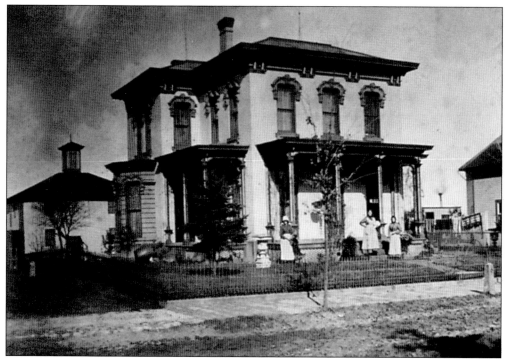

The Pontius House, which sat at 603 East Main Street, dated back to 1876. Before Andrew VanBurren Pontius (1840–1923) owned this property, it had been in the hands of Charles Juilliard, Joshua Derr, Peter Eck, and others. Pontius's great-great-grandfather Johannes Friedrich Pontius came from Germany. Several generations of the Pontius family (including Andrew) are buried in the Henry Warstler Lutheran Cemetery in Canton.

Charles "Chuck" Leuenberger (1926–2010) owned Chuck's Men's and Boy's Fashions in downtown Louisville (where Beatty's Sport Shop is currently). His classy store was paneled with dark wainscoting; dress slacks and shirts were displayed in neat piles on islands in the middle of the sales floor. Chuck tended his shop as a real gentleman. This undated photograph of Chuck might have been from a Constitution Day event or the Centi-Silverama.

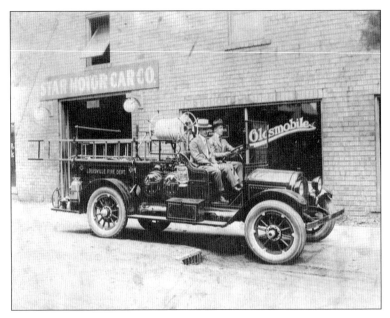

Fires were common occurrences at the turn of the 20th century. That is why it was particularly important that Louisville purchase its first motorized fire truck, which reduced the amount of time that it would take for firefighters to arrive at the scene of a fire. Pictured here is the city's first fire truck in front of the Star Motor Car Company.

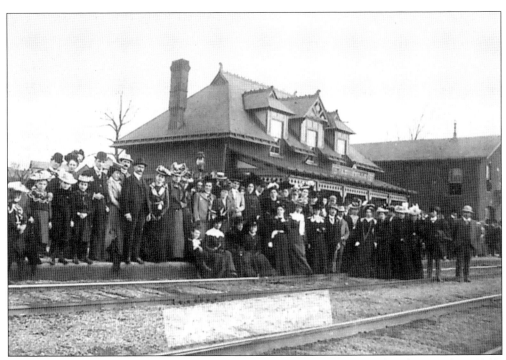

This image of the Louisville train depot in 1900 evinces that it was a popular place. Built in 1860, the depot would have been a place of shelter when people waited for trains or awaited those they were expecting there. The first train came through Louisville in 1852. Louisville's centennial booklet (1934) states that "officials and a band were aboard the [first] train, and people for miles around came to town to see the novel sight."

Sp. Roland John "Noonie" Grunder (1947-1967) was Louisville's first casualty of the Vietnam War (1955-1975). He died on November 24, 1967, and he rests now in Union Cemetery in Louisville with both of his parents (section 9, row 1). He was in the Army (Company D, 2nd Battalion, 5th Cavalry Regiment, 1st Cavalry Division).

The Knights of Columbus is a Catholic fraternal organization that upholds the principles of charity, unity, fraternity, and patriotism. The organization is built on integrity, professionalism, excellence, and respect. The Louisville chapter owned a hall where concerts would be held among other things. This photograph shows some of the Knights from the Louisville chapter in the Constitution Parade in the 1980s.

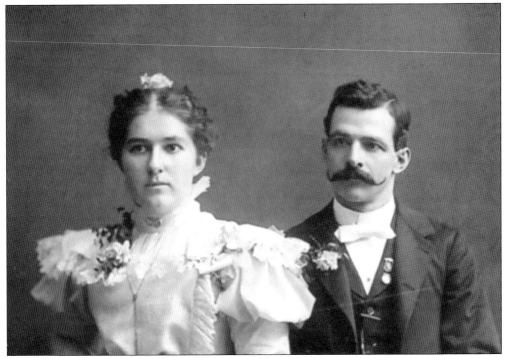

One of the most important people in Louisville history who is virtually unknown today is Ephraim Monroe Youtz (1868–1945), an early photographer. While there were other photographers with studios in Louisville, Youtz seems to have taken more photographs than any other. His prosperity was clear in the two additions he had to make to his studio in 1898 and 1902. This is Ephraim and his wife, Clara (Blair) Youtz (1878–1898).

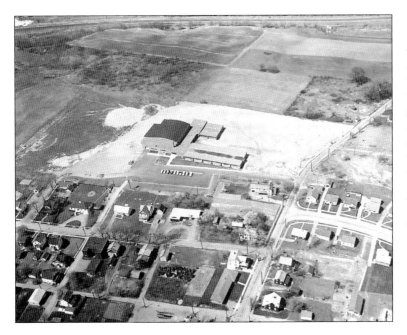

This aerial view of the old Louisville Elementary School building shows the site just after its construction was complete. It was replaced a little over 10 years ago on the same site with a much more modern-looking building. Notice that the Louisville Public Library had not yet moved to its current location to the west (left) of the school building.

Frank "Cap" Guittard (1864–1959) was a police captain from 1899 to 1944. Here, he strikes a pose in front of an unidentified downtown store. He is buried in Union Cemetery in Louisville with his wife, Sally.

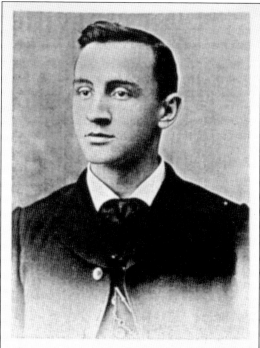

John C. Prenot - Editor of Louisville "Herald" 1897-1927.

John C. Prenot (1870–1942) was the editor of the *Louisville Herald* from 1897 to 1927 after he purchased it from Augustus Juilliard. He was born and educated in Louisville and learned to set type under the original owner, L.P. Bissel, who started the business in 1887. Prenot is buried in Union Cemetery in Louisville.

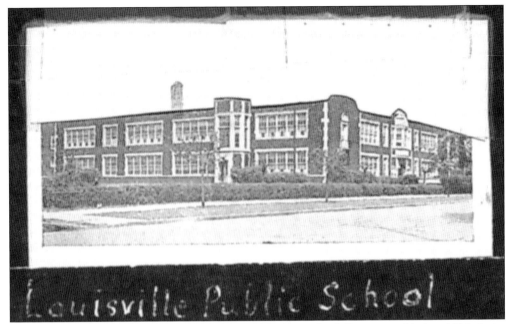

Louisville Public School

This picture is of the old Louisville High School before a third floor was added in 1930. In its later years, it served as the middle school after the new high school was completed on Nickel Plate Street. Once the school district went forward with plans to build a new middle school close to the current high school, this building was razed in 2009.

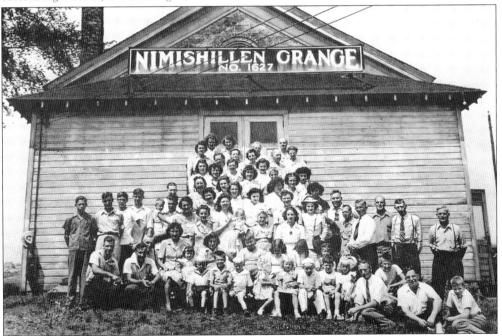

The Grange organization started in the 1860s as an advocacy group—a union—for farmers. Over time it dealt less with things like advocating for fair grain prices and more with providing a social outlet for those living in rural areas. This Nimishillen Grange photograph of members in front of their previous building is undated, and there are no names identifying the people in the picture.

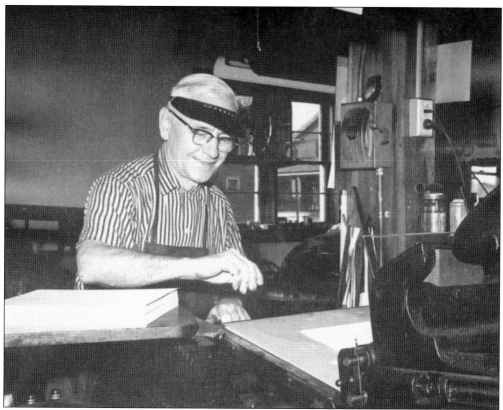

Louis Clapper (1887–1962) was the owner and editor of the *Louisville Herald*. His great-grandfather Henry came from Bedford County, Pennsylvania, and settled in Mapleton, Ohio. Louis and his wife, Tirzah (1889–1973), are buried in Union Cemetery. Their tombstone identifies their earthly vocation: "Owners, Publishers, Editors of the *Louisville Herald* since 1927."

Howard Wilson was a highly respected coach and principal at Louisville High School. With the nickname "Peg," he was raised and educated in Louisville. The Louisville-Nimishillen Historical Society has a number of things that belonged to him, including his baseball bat and his report card.

Louisville.--A Bird's

e View.

Bird's-eye views of towns and farms were extremely popular at the end of the 19th century. The work of Dr. Don Yoder (1921–2015) has called attention to such pictures in printed county atlases, and the work of Kathleen Wieschaus-Voss has helped to expose this perspective in the folk art drawings of Ferdinand Brader (1833–1901), who traveled through Nimishillen Township and drew farms and businesses to earn his keep until going to the next location to sketch more. This photograph, labeled "Louisville—A Bird's Eye View," while it is not taken from a higher elevation, is nonetheless an early panoramic view of the town, captured photographically from afar. Saint Louis Church is visible on the left side of the image. The large open space of the farmland gives essential context to the photograph.

On August 20, 1979, this was the scene at the Louisville Public Library. Throughout the last 20 years, the directors and staff at the library have made an even bigger effort to make the library a hub of community activity. From hot air balloons and summer reading programs to makerspace projects and 3D printing, Louisville is fortunate to have its library and should support it. Even though the community has benefited from these efforts, levies that have been put on ballots to secure more funding have failed. Recently, the library director announced that the library will move yet again to a new home at Metzger Park in the near future. Because voters have declined to help build the building with tax money, the library will pay for the building on its own.

North Nimishillen Elementary School is the only small grade school still standing in the Louisville school district. At one time, "North Nim," as locals call it, was one of four elementary schools in the district. Along with Fairhope Elementary School, Pleasant Grove Elementary School, and Louisville Elementary School, North Nim prepared children for the higher grades. Alumni of North Nim struggled to keep this school and won.

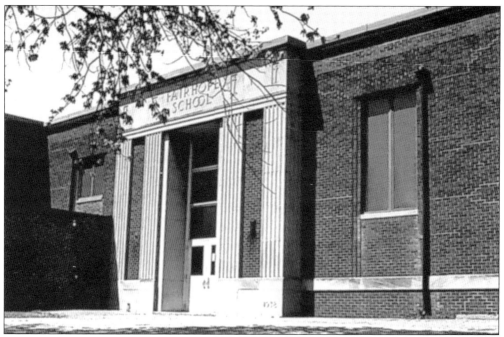

Fairhope Elementary School provided primary education for the children of the school district on the west end of town. When the school district built the new Louisville Elementary School building and consolidated, this school was eliminated. Now, children in that part of town ride a bus to Louisville Elementary on Nickel Plate Street.

Pleasant Grove Elementary School was similar in size to Fairhope Elementary School. It served the community on the east side of Louisville. When the school district consolidated the elementary schools, Pleasant Grove was eliminated. Alumni had their last chance to see their former school the day that the contents of the building were sold at auction.

In 1989, the US Post Office built this modern structure on North Chapel Street. It had been about 75 years since Louisville had gotten a new post office. Unlike the previous building on East Main Street, this new building was solely utilitarian in style and not aesthetic.

Robert "Bob" Joseph Gladieux, a lauded pro football running back, played for the Boston Patriots, Buffalo Bills, and New England Patriots. Born on January 2, 1947, in Louisville, he also played college football for Notre Dame. At one time, he also played for the New York Stars in the World Football League.

Being an agricultural area, the 4-H Club has been an important part of Louisville and the surrounding township. Youth have enjoyed showing their animals and participating in other events at the Stark County Fair with the training and preparation that they received from the dedicated adults who serve as mentors in this organization over the years.

The Constitution Queen is given pride of place during the Constitution Day festivities. Here is the 1980 queen, Kelly Hostetler, riding in the Constitution Parade in a red convertible sports car. Alliance, Ohio, has a similar tradition during its Carnation festivities and parade.

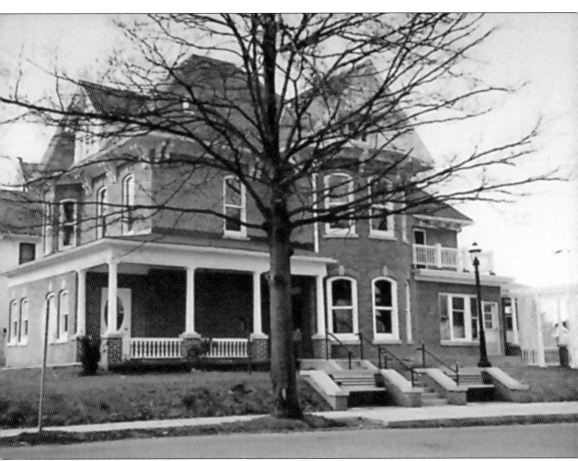

The Charles Louis Juilliard House is located at 523 East Main Street. It originally lacked the tower on the southwest corner of the house, and it likely had an open porch wrap around the south to the east side. Charles (1823–1902) was born near Montgelaird, France, as were his parents. He participated in the gold rush in 1849 by selling mining tools to those trying to find gold. He spent some time in Bucyrus, and then after staying there for three years, he moved back to Nimishillen Township, where he married Louise Feusir (1838–1908). He is buried in Union Cemetery along with Louise and other members of the Juilliard family. The grand family monument that stands with individual stones around it is much like the Julliard House, which dwarfs other houses around it.

Mary C. Metzger (1882–1971) bequeathed her 88-acre farm to the city of Louisville for the sole purpose of creating a public park. The 200 parking spaces make this park ideal for large parties and gatherings when using the pavilions and the playground. Walking paths loop around the property. Each path is marked with markers for those who are walking or running the paths in order to keep track of their activity. Fenced-in dog areas allow people to bring their dogs and let them run free. Louisville's youth soccer club plays games here. (Photographs by Justus Grimminger.)

Eight

THINGS FORGOTTEN

Louisville has had its share of problems. Some were "acts of God," like the frost on June 6, 1859, the blizzard in late April 1901, or the gale of June 4, 1911. In the last instance, according to the *Louisville Herald*, parishioners in Saint Louis Church "prayed and cried by turns. Great pieces of the roof were blown away . . . the interior of the building was damaged by water . . . the roofs of the Clark, Hamilton, and Keim buildings were blown off as though they were . . . paper." Rainwater flooded properties along the railroad tracks, where the water rose highest in 1950 and 2008 among other times. Fires also did damage, as in 1922, when the Schilling Building burned and was "practically a total loss," as reported in the *Louisville Herald* on December 28, 1922.

Freak accidents claimed lives. The earliest one might have been when Henry Hoover brought the first steam boiler and engine to the area to power his sawmill, and the boiler exploded on August 30, 1836, killing three men. Seventy years later, a similar explosion occurred at the Louisville Brick and Tile Company. Railroad accidents claimed a number of lives, as in 1880, when two orphan boys from Saint Louis orphanage were killed at the Main Street crossing. Later, in 1905, August Miller, his wife, and guests met their death at the Nickleplate crossing.

There are other things that are forgotten. The Ku Klux Klan had regular events in Louisville with the participation of law enforcement and other influential figures. The town was a dangerous place for non-Caucasians. A more recent self-generated issue in Louisville was the 2016 teacher strike that polarized the city into pro-teacher and pro–school board camps; teachers demanded fairer teacher contracts, resulting in push back from the superintendent and school board. In 2020, a "mobile rally" ("the Trump Train") came through Louisville to keep the previous president in office. The same zeal was displayed in profane flags against future president Biden. Political unrest hit Louisville, as it had most American towns.

Klan Members Attend Services at U. B. Church

About two hundred and fifty members of the K. K. K. attended divine services at the United Brethren church Sunday evening. They wore their hoods and gowns. There were a number of ladies among the number and they also wore the hoods and gowns. Rev. J. J. Wagner, pastor of the United Brethren church, preached the sermon choosing for his subject "Our attitude and tasks to our fellow men." His sermon was closely followed and very appropriate. Miss Jeanne Hayes, sang a beautiful solo. A member of the Klan delivered an interesting address. He explained the attitude and purpose of the Klan, and said an effort was being made to interest more people in the organization. An offering was taken and presented to the United Brethren church. A member of the Klan made the presentation speech. He said in part, "In the church stability and strength are assured if there is a nucleus of outstanding characters who are possessed of conviction and vision, and endowed with the spirit which animates the real church. The rest will be brought into harmony by their example.

This newspaper clipping from the March 11, 1926, issue of the *Herald* offers a better picture of just how far the Klan had encroached on the institutions of Louisville, even the churches. It is not certain how the Klansmen took the words of the pastor with his address, which the newspaper documents as "Our attitude and tasks to our fellow man." Further, it is not certain why the Klan met in the Brethren church. Regardless, the address given by the Klansman looks on paper like it is an echo of what the pastor preached, but the veiled language likely points to a very different message. Today, the First Brethren Church in Louisville has been a leader in showing how to diversify the community and reflect the teaching of the Bible when it comes to loving and serving neighbors. (Used with permission of the *Louisville Herald*.)

Klan Holds Meeting
on City Hall Grounds

The K. K. K. held a meeting on the city hall grounds Friday night. A parade which was formed on East Main street, headed by a band and a ladies' drum corps, marched through the main streets of the town before the meeting. About one hundred members of the klan were in line. The speaker of the evening was quite eloquent and urged all to vote for and support the parties who are up for office who will make the best officials, regardless of party affiliation. He said that there are too many people in this country of ours who are continually finding fault with the officials for not enforcing the law, and, the fault-finders themselves are the ones who would craw-fish should they be asked to assist in cleaning up a community. He said to be 100 per cent American means more than waving the American flag and shouting your lungs out. At the close of the address the parade again formed and marched east on Main street to Nickel Plate street where they disbanded.

Herald 8-4-1927 p.1

The Klan used public grounds in the city to hold rallies. This clipping shows that there were political implications for the Klan, which spread a message that resonated with conservatives in the town. The newspaper article says that the Klan was endorsing whatever candidates would uphold their values. This rally that happened on August 4, 1927, involved a lot of noise, from the speakers to the women's drum corps that beat their drums up and down the streets of Louisville to bring people out of their homes and drive home the message of their organization. The article reports that there was a parade of sorts, something that, according to legend, had happened on many occasions in the first half and even the middle of the 20th century. The nationalistic rhetoric of the clipping sounds similar to some more recent political voices in America. (Used with permission of the *Louisville Herald*.)

Work-related accidents were much more common because there was no regulation or oversight of safety 100 years ago. This boiler accident happened in 1906. Much like the 1836 boiler explosion mentioned in the introduction to this chapter, this incident did damage that took some time and money to repair. Author Mike Brunner cites an account of an 1896 boiler explosion at the Louisville Brick and Tile Company: "A 150 horse-power boiler . . . exploded on the morning of August 13, completely wrecking the building. The engineer was killed and six men wounded. The boiler was blown through two kilns, a distance of 75 feet."

On November 2, 2016, all 180 members of the Louisville School District teaching staff picketed because they disagreed with what they believed was unclear language in the contracts the school district offered them concerning evaluations and layoffs. The previous contract had expired in June of that year. On October 24, 2016, more than 500 people attended a meeting of the board of education (above). The majority of attendees were supportive of the teachers, according to the *Canton Repository* article about the meeting. In response to the teachers and growing tension, the school board rented metal shipping containers at a cost of over $300,000 to block the picket line from parents' view. The board also canceled some of the scheduled meetings or moved them into executive sessions. The strike ended in late November. (Photographs used by agreement. © *The Repository*—USA TODAY NETWORK.)

A photo of the big snow of 1901. In the picture is John E. "Teddy" Moinet, with shovel, and Edward Thoman.

On April 20, 1901, a blizzard hit Louisville. It was so bad that the *Herald* named it one of the three most notable natural disasters in Louisville's history up until 1911. This vignette of downtown Louisville evinces just how bad the snow got for residents. Molly Stark Sanatorium (below) was one of 25 tuberculosis hospitals in Ohio. Starting in 1929, this institution provided sunlight and fresh air as part of the patient plan of care. Albert Thayer, the New Castle, Pennsylvania, architect, designed this facility in the Spanish Revival style to allow plenty of opportunity for both natural light and air flow. Copious windows, balconies, and verandas brought the outside into the building for the good of the patients. In 1938, the Works Progress Administration installed 1,200 feet of underground tunnels. By 1956, tuberculosis was no longer the threat it had been due to medical advances, thus the name of the facility changed to Molly Stark Hospital to indicate its broader scope of practice. The facility ceased operation in 1995, and Stark Parks bought the grounds in 2009 to expand public park space.

BIBLIOGRAPHY

A Sketch of Saint Louis Church as a Centennial Memorial, 1838–1938. Louisville, OH: Saint Louis Church, 1938.

Brunner, Mark. *Early Business in Nimishillen Township, Stark County, Ohio.* Privately Printed, 2013.

———. *Historical Architecture, Nimishillen Township, Stark County, Ohio.* Privately Printed, 2012.

Canton Repository.

Danner, John. *Old Landmarks of Canton and Stark County, Ohio.* Logansport, IN: B.F. Bowen, 1904.

Grimminger, Daniel Jay. *Sacred Song and the Pennsylvania Dutch.* Rochester, NY: University of Rochester Press, 2012.

Gress, Allen E. *Paradise United Church of Christ: One Hundred Fifty Years in the Service of Christ 1863–2013.* Louisville, OH: Paradise United Church of Christ, 2013.

Hazen, Robert M. *The Music Men: An Illustrated History of Brass Bands in America, 1800–1920.* Washington, DC: Smithsonian Books, 1987.

Israel's Union Church (Paris, Stark County, Ohio) *Kirchenbuch* (German script parish register), 1829.

Kaufman, William, and Orrin Kaufman. *Atlas of Stark County, Ohio.* Canton, OH: the Ohio Map and Atlas Co., 1896.

Lehman, John H. *A Standard History of Stark County.* Vol. II. Chicago: Lewis Publishing Company, n.d.

Louisville Herald.

Perrin, William Henry. *History of Stark County.* Chicago: Baskin and Battey Historical Publishers, 1881.

Sanders, Wilbur R. "Frederic Fainot." Typed manuscript, Louisville-Nimishillen Historical Society, n.d.

Shoemaker, H. Jay. *History of Paradise Church.* Alliance, OH: Review Printing Company, 1963.

Smith, Kenneth R. *Louisville: The Way it Was, 1834–1990.* 2nd ed. Canton, OH: Claymore Publishing, 1997.

Wieschaus-Voss, Kathleen, ed. *The Legacy of Ferdinand A. Brader.* Canton, OH: Center for the Study of Art in Rural America, 2014.

DISCOVER THOUSANDS OF LOCAL HISTORY BOOKS FEATURING MILLIONS OF VINTAGE IMAGES

Arcadia Publishing, the leading local history publisher in the United States, is committed to making history accessible and meaningful through publishing books that celebrate and preserve the heritage of America's people and places.

Find more books like this at
www.arcadiapublishing.com

Search for your hometown history, your old stomping grounds, and even your favorite sports team.